MINIMALISM

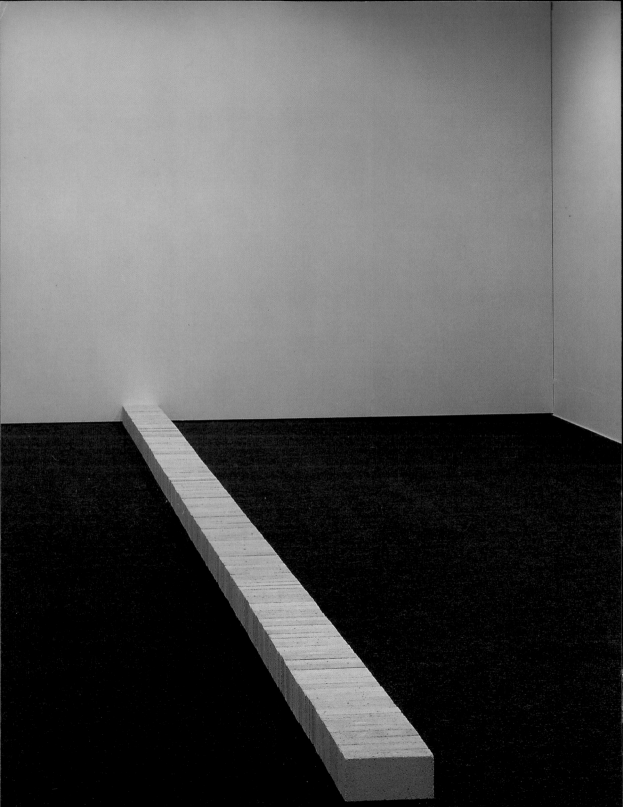

MOVEMENTS IN MODERN ART

MINIMALISM

DAVID BATCHELOR

 CAMBRIDGE
UNIVERSITY PRESS

For my mother

PUBLISHED BY THE PRESS SYNDICATE OF THE
UNIVERSITY OF CAMBRIDGE
The Pitt Building, Trumpington Street, Cambridge CB2 1RP,
United Kingdom

CAMBRIDGE UNIVERSITY PRESS
The Edinburgh Building, Cambridge CB2 2RU, United Kingdom
40 West 20th Street, New York, NY 10011-4211, USA
10 Stamford Road, Oakleigh, Melbourne, 3166, Australia

First published by Tate Gallery Publishing Ltd, London 1997

Cover designed by Slatter-Anderson, London
Book designed by Isambard Thomas
Typeset in Monotype Centaur and
Adobe Franklin Gothin

Printed in Hong Kong by South Sea International Press Ltd

Library of Congress Cataloguing-in-Publication Data has been applied for

A catalogue record for this book is available from the British Library

Measurements are given in centimetres, height before width
before depth, followed by inches in brackets

Cover:
Dan Flavin, *Ursula's One and Two Picture 1/3* 1964 (fig.31)

Frontispiece:
Carl Andre, *Lever* 1966 (fig.53)

ISBN 0 521 62759 1

Acknowledgments

I would like to thank everyone who
helped make this volume possible
and especially: Peter Ballantine,
Marianne Stockebrand, Susanna
Singer, Prudence Fairweather,
Chrissie Iles, Hester van Royen,
Alison Jaques, Eva Meyer-Herman,
Paul Wood, Briony Fer, Alex Potts,
Teresa Gleadowe, John Klein and,
most of all, Gill Perry.

Contents

INTRODUCTION

> I find the invitation to participate in your untitled 'minimal art' exhibition
> objectionable. I do not enjoy the designation of my proposal as that of some
> dubious, facetious, epithetical, proto-historic 'movement'.
> Dan Flavin, 1967

There is a problem with Minimal Art: it never existed. At least, for most of
the artists who are usually grouped under that label, it was at best meaningless
and at worst a frustratingly misleading term. Nevertheless, between 1963 and
1965 a number of artists based in New York began independently to exhibit
three-dimensional work which, for a number of commentators, had enough
in common for it to be discussed, exhibited, and otherwise made public, as
something like a movement. A number of names were coined for this new
work – including 'ABC Art', 'Rejective Art', and 'Literalism' – but 'Minimal
Art' or 'Minimalism' was the label that stuck. And if Richard Wollheim's
essay 'Minimal Art', published in early 1965, really did christen the movement
whose existence is denied by the artists associated with it, then it is a fitting
irony, for Wollheim's text discusses none of the artists whose work
subsequently came to be branded 'Minimal'.

Since the mid-1960s the adjective Minimalist has been pulled and stretched
to cover such a wide range of sculpture and painting (and other art forms)
that it has lost whatever purposeful limits it may (or may not) have once had.
Almost any approximately geometric, vaguely austere, more-or-less
monochromatic, and generally abstract-looking work has been or is likely to

get labelled Minimal at one time or another. And, conversely, almost anything labelled Minimal will automatically be seen by some as starkly austere, monochromatic, abstract, and so forth, irrespective of its actual appearance. Moreover, group names like Minimalism do not just serve to homogenise bodies of work which might be only superficially alike; they simultaneously detach that work from other material which may only be superficially different. The history of art after the 1950s is strewn with new classifications: 'Neo-Dada', 'Assemblage', 'Pop Art', 'Post Painterly Abstraction', etc; and for the most part work listed under one heading has been isolated – in criticism, exhibitions, art history and journalism – and kept away from work held under any other heading. Only relatively infrequently have commentators noted relationships between work from apparently exclusive categories, although arguably the artists have been doing so all along.

Class names are schematic; that is both their value and their limitation. It is not my aim in this book to come up with a more true or accurate or lasting definition of Minimal Art. Rather than setting out to fill up a hollow category with as many objects as can be shoe-horned into it, my starting point will be the work of the five artists who, in most accounts of the period, get celebrated or blamed for bringing Minimal Art into being. Those artists are Carl Andre (b.1935), Dan Flavin (1933–1996), Donald Judd (1928–1994), Sol LeWitt (b.1928) and Robert Morris (b.1931). There is, I believe, enough that each of these artist's work has in common with that of the others to make it worth discussing them together in the same essay. But at the same time the similarities that can be shown to exist are also the ground upon which differences are developed. In some instances the differences far outweigh the similarities, and the work of each artist will also have to be discussed separately.

The work made by these artists represents more than just a period style quickly superseded by another in the ever-accelerating demand for new-looking art. The work is historically important, I believe, because it substantially changed what art could look like, how it could be made and what it could be made from. And this work remains important not least because, over three decades later, a great deal of contemporary art is built out of the same materials and by similar means, whether or not it is made to serve the same or similar ends.

Before going on to look at the work of these five artists there is one other point to note: just as there is no clear consensus as to what Minimal Art is or was, so there is no agreement as to what works of Minimalist art might mean or represent. On the contrary, interpretations of Minimal Art are often quite strikingly divergent. Furthermore, there is often a marked intensity about these critical commentaries, and not just from the period in which the work was made. Some of the most strident opposition to the perceived ethos of Minimalism has been voiced within the last five or so years. In terms of the broad periodisation of post-war art, Minimal Art has been held up by some commentators as the apotheosis of 'modernist idealism', though not, it must be said, by modernist critics themselves. Clement Greenberg and Michael Fried, for example, argued that the art of Andre, Judd, Morris *et al*, was exactly

at odds with the achievements of high modernism. Other commentators have seen in Minimal Art the initiation of a 'postmodernist critique of its institutional and discursive conditions' (Foster 1987). The art itself has often been seen in terms of a kind of cultural temperance movement: 'a classicising reaction against the Romantic exuberance and self-celebration of 1950s Abstract Expressionist painting' (Baker 1988). The regular box-like or cubic forms of a LeWitt or a Judd are habitually classified as 'idealistic', as 'rational' and as 'classical', although there have been a few commentators who have seen just the opposite in exactly the same work: something 'sensuous' and 'irrational' and 'obsessive'. Thus by extension Minimalism has been held by some to epitomise 'a world without fragmentation, a world of seamless unity' (Colpitt 1990), whereas for others it shows us 'a world without a centre, a world of substitutions and transpositions nowhere legitimated by the

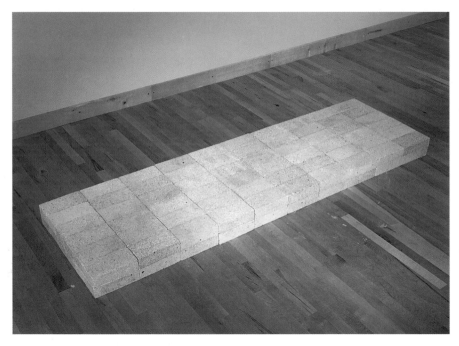

revelations of a transcendental subject' (Krauss 1977). Thus also Minimalism has been taken as the analogue of 1960s counter-culture: 'atheistic, communistic, materialistic', to use Andre's words; and it has been identified as the art of the status quo: revealing 'the face of capital, the face of authority, the face of the father' (Chave 1990).

So much for the category. Consider now the following works (figs.1–10): *Equivalent VIII*, 1966, and *144 Magnesium Square*, 1969 by Carl Andre; *'Monument' for V. Tatlin*, 1966–9, and *Untitled (to the 'innovator' of Wheeling Peachblow)*, 1968 by Dan Flavin; *Untitled*, 1970 and *Untitled*, 1972 by Donald Judd; *Modular Floor Structure*, 1966, and *Five Modular Structures (Sequential Permutations on the Number Five)*, 1972 by Sol LeWitt; *Untitled*, 1965, and *Untitled*, 1965/71 by Robert Morris.

What do these works have in common? Each is a relatively uncomplicated

1 *left*
Carl Andre

Equivalent VIII 1966

Firebricks
12.7 × 68.6 × 229.2
(5 × 27 × 90¼)
Tate Gallery

2 *above right*
Carl Andre

144 Magnesium Square 1969

Magnesium
1 × 365.8 × 365.8
(½ × 144 × 144)
Tate Gallery

3 *right*
Dan Flavin

'Monument' for V. Tatlin 1966–9

Fluorescent light and fittings
305.4 × 58.4 × 8.9
(120¼ × 23 × 3½)
Tate Gallery

4 *far right*
Dan Flavin

Untitled (to the 'innovator' of Wheeling Peachblow) 1968

Fluorescent light and fittings
245 × 244.3 × 14.5
(96½ × 96½ × 5¾)
The Museum of Modern Art, New York. Helena Rubinstein Fund

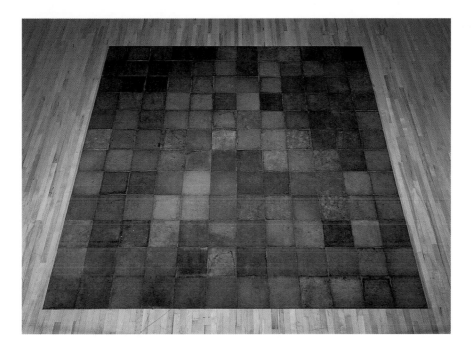

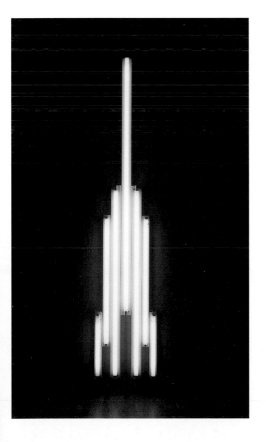

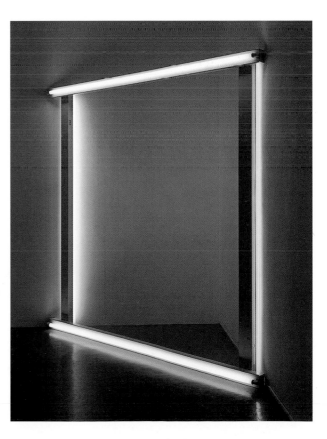

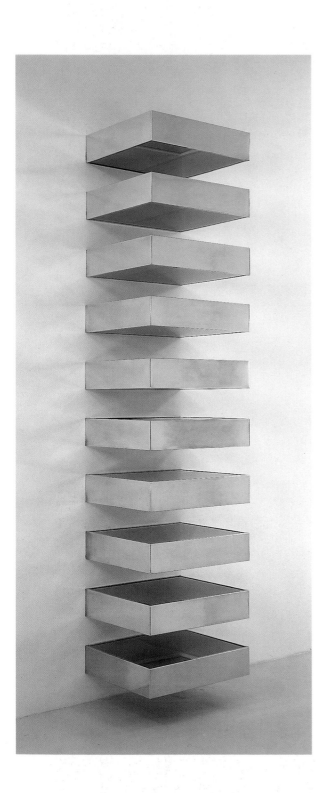

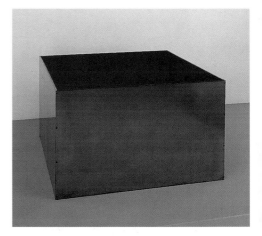

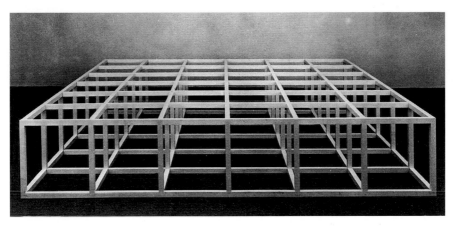

three-dimensional composition: all are based on a square, cubic, or rectangular format, except Flavin's *'Monument' for V. Tatlin* which is nevertheless regular and symmetrical. In most of the work one basic regular unit or module is repeated – between two and 120 times – to form an overall regular shape; Judd's floor-based open cube is the only 'singular' work, although this involves repetition of its four equal sides. This repetition is generally relatively artless: 'one thing after another' as Judd put it. The simple forms are not complicated by dynamic or unstable arrangement, and nor is there any added ornamentation. They are resolutely abstract. And they are quite literal: the materials are not disguised or manipulated to resemble something they are not. None of the work is framed or placed on a plinth. They are not separated by such devices from the space of the viewer. Seven of the ten rest directly on the floor; the two works by Flavin are fixed directly to the wall, as is most but not all of his work. Judd has also regularly used the wall-plane in his

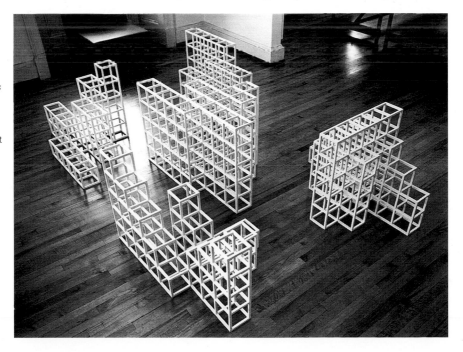

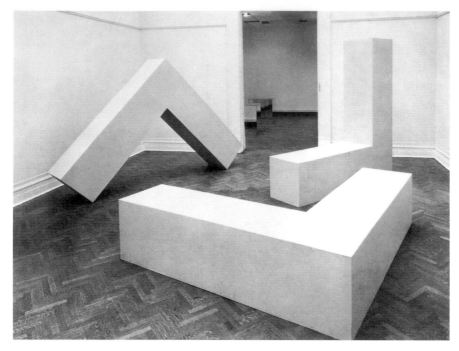

9
Robert Morris
Untitled 1965
Three pieces, each
243.8 × 243.8 × 60.9
(96 × 96 × 24)
(Destroyed)

three-dimensional work, as has LeWitt, if more occasionally. The two works by LeWitt, one by Morris, and a section of the floor-based Judd, use applied colour; and colour in such work usually has a flat, inexpressive and matter-of-fact quality. Judd has used coloured acrylic sheet and Flavin often employs coloured fluorescent tubes; the white of the LeWitt and the grey of the Morris is in each case more of a paint-job than painting proper. The works are assembled and arranged rather than crafted and composed. They are not carved or modelled but welded, screwed, glued, bolted or simply stacked. The autographic trace of the expressive artist is eliminated. The materials each of

10
Robert Morris
Untitled 1965/71
Mirror plate glass and wood
91.4 × 91.4 × 91.4
(36 × 36 × 36)
Tate Gallery

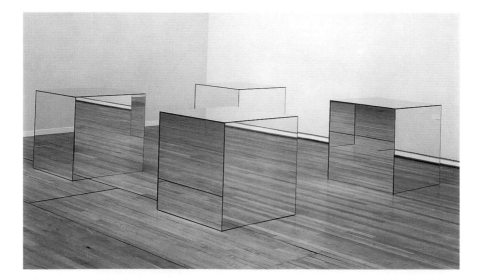

the artists has used are more industrial than artistic in a traditional sense; available from builders' merchants and the like rather than a fine art or craft supplier: steel, brick, plywood, aluminium, copper, fluorescent light, mirrored glass.

What else do these works have in common? The majority were made during the second half of the 1960s; they were all made in New York; they were all made by men, all of whom were in their early thirties, and all of whom are white. But what, if anything, should we infer from these facts? That Minimal Art is a white, male, East-Coast aesthetic? Perhaps. The work does have a light-industrial look about it, and shop-floors are traditionally male – if not necessarily white, or East-Coast, or middle-class – domains. On the other hand, there might be something rather unhelpful about making this kind of match between various forms and materials on the one hand, and a set of assumptions about a gender or a race or a class on the other. It begins to homogenise a body of work before we have properly begun to look at it; and to do so under a label which is, at best, an extreme abstraction. What I take to be some of the most important aspects of Minimal Art do not conform so readily to the typical predicates of the label 'masculine': it is, for example, often and in varying degrees decorative, light, and colourful. In a few accounts of this work, assumptions about its overriding masculinity or about its cool rationality have blinded its commentators to these less regular and less predictable and, to my mind, more interesting features. In addition, it is worth noting here that the majority of the more sympathetic, insightful and interesting contemporary accounts of Minimal Art were often written by women – Barbara Reise, Barbara Rose, Lucy Lippard and Rosalind Krauss; and that many of the most interesting developments or transformations of Minimalism have been initiated by women artists – first and foremost by Eva Hesse, but also by several artists from more recent generations. Furthermore, other artists such as Rasheed Araeen, who had begun to make comparable or related work in the mid-1960s, whilst male, were neither American nor white. If, for whatever reasons, that which has been identified as Minimal Art was begun by a few men – and remember, the artists themselves never recognised this grouping – that in itself does not guarantee the 'masculinity' of the art. Certainly its continuation in art, criticism, theory and history has been anything but an exclusively male affair. Questions of gender, ethnicity and class cannot be suppressed; but at the same time as we raise them we might also have to suspend them – at least until it is clearer what it is we are looking at.

So: industrial materials, modular units, regular or symmetrical or gridded arrangements, a kind of directness in the use and presentation of materials, and absence of craft or ornamentation or ornamental composition; this forms a kind of common ground, and a point of departure for the present essay. But how each of the artists arrived at this common ground, and what they subsequently made of it, cannot be laid out so simply or straightforwardly.

I

11
Robert Rauschenberg
Charlene 1954
Oil and collage on wood
panels
226 × 284.5
(89 × 112)
Stedelijk Museum,
Amsterdam

OF PAINTING AND SCULPTURE

By the 1950s the category 'painting' had expanded – or contracted – to include
works made from a single, uniform, unbroken and unmodulated field of
colour laid over a flat rectangular surface. The category 'sculpture' by that
time had long included – or had been long assailed by – a range of objects
plucked from the world of non-art to which nothing had been added and
nothing taken away. The 'monochrome' and the 'readymade' had become
established facts of art, and even if they were not universally admired facts,
they were facts which nonetheless carried with them profound implications
for art. Then as now, serious discussion about art could not proceed far
without acknowledging the presence or the possibility of such work. And if
the outer limits of painting and sculpture appeared to have been touched
upon by certain works, so some other taken-for-granted boundaries were also
put under threat. In particular the dividing line between painting and
sculpture had itself become far from clear. For a number of artists and critics,
this was a dynamic and creative uncertainty; for others this uncertainty
represented little short of the negation of art.

In 'Specific Objects' (1965), an essay which has come to be read as a kind of
manifesto of Minimalism, but was never intended as such, Donald Judd
opened with the now famous remark that 'Half or more of the best new work
in the last few years has been neither painting nor sculpture'. Preferring the
term 'three-dimensional work' or 'objects', he listed a wide range of work
which fell into this category. In the same year as 'Specific Objects' was
published, Sol LeWitt made the first of what have become his signature

works, the open modular cubes. Like Judd, LeWitt sought to distinguish these works from a tradition of sculpture, and referred to them instead as 'structures'. Dan Flavin refers to his fluorescent light work as 'proposals', and has objected to its being labelled sculpture or connected to a tradition of painting. Robert Morris, on the other hand, rather than resisting the categorisation of his work in conventional terms, published a series of essays in *Artforum* magazine between 1966 and 1969 under the title 'Notes on Sculpture'. Morris may have been asserting his independence from his contemporaries by hanging on to 'sculpture' as a positive term, but it did not last long. Having objected to the terms 'structure' and 'object' and 'specific object' in the earlier parts of 'Notes on Sculpture', by part III (June 1967) he was speaking freely of 'the new three-dimensional work'. A little under two years later (in part IV, April 1969) he would state 'Sculpture stopped dead and objects began', although the sub-title of the essay let the reader know that his own work had moved 'Beyond Objects'. Only Carl Andre continues to use the term 'sculpture' without qualification in reference to his work.

It was not just among these artists that the terms 'painting' and 'sculpture' had become problematic. By the mid-1950s Robert Rauschenberg had begun to title his large collage-derived canvases 'Combines' (fig.11), and nor did the work of Jasper Johns perch any more easily on one or other of the traditional branches of art (fig.12). It was not just that both these artists had begun to attach 'found' objects or everyday materials to the surface of their canvases. For the critic Leo Steinberg, Rauchenberg's work – from the time of his monochrome canvases of the early 1950s (fig.13) – marked a highly significant turn in the development of painting. This was a turn away from the idea of painting as an illusion of space behind the literal plane of the canvas, and toward the 'flatbed picture plane' in which the canvas becomes a surface more like a table-top or a pin-board. Material of almost any kind could be embedded in or scattered over this hard surface in a way which made the surface 'no longer the analogue of a visual experience but of operational processes'. For Steinberg, this surface was marked by opacity rather than transparency, literalness rather than illusion, was implicated in a world which is made rather than seen, and referenced experience embedded in urban culture rather than in nature. It was a logical effect of this reorientation of the picture-plane that the distinctions between painting and sculpture began to break down. In abandoning the illusion of three dimensions, painting took to those dimensions literally. And became something else in the process.

Steinberg's was an essay about contemporary criticism as much as it was

about contemporary art. Its title, 'Other Criteria', implied in part that criteria other than those of Greenberg could be applied to the analysis of art, whether modern or historical. First, the idea of the flatbed picture plane offered an alternative interpretation of the 'flatness' which Greenberg had, in 'Modernist Painting' (1961) identified as the central orientation of modern painting. For Greenberg flatness was the outcome of the logic of painting's drive towards self-definition. For Steinberg, flatness was the analogue in art of the experience of modernity. Second, for Greenberg 'self-definition' meant in part the separation of each of the arts from one another. For Steinberg, the flatbed picture plane meant the cancellation of the different domains of painting and sculpture. Third, the development of art had, for Greenberg, been relatively continuous since the time of Manet; painting of the 1960s was part of a dynamic initiated in the 1860s. For Steinberg the early work of Rauschenberg (and Dubuffet, Johns and others) marked a radical break with the history of painting since the Renaissance.

Judd's and Morris's published comments have something in common with Steinberg's, including an implied distance from Greenberg's formulations about the development of painting. In 'Specific Objects', Judd wasn't *proposing* a new kind of work which was neither-painting-nor-sculpture, so much as acknowledging its wide-ranging presence in art. Over forty contemporary artists were mentioned in the essay. The list included Morris and Flavin; also Rauschenberg, Johns, Frank Stella and Kenneth Noland; a few European artists, Yves Klein and Arman amongst them; and a diverse range of American work from Claes Oldenberg, John Chamberlain and Andy Warhol to George Brecht, George Segal and Ed Kienholz. Neither-painting-nor-sculpture was for Judd a condition of a wide variety of new art; 'objectness' characterised both abstract and figurative, European and American, East Coast and West Coast, Pop and Minimal and other areas of art. But objectness was also a new occurrence, and was therefore something that marked (or helped to mark) a significant break with art of the past — and with pre-war European art in particular.

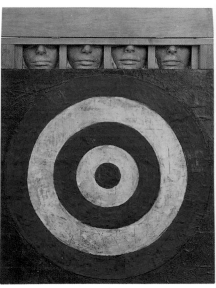

To call something an object rather than a painting carries certain implications (as does calling something an object rather than a sculpture — but not necessarily the same ones). In an interview by Bruce Glaser in 1964, with Judd and the painter Frank Stella (figs.14, 15), Stella stressed: 'My painting is based on the fact that only what can be seen there *is* there. It really is an object.' This remark anticipates Steinberg's comments about the new-found literalness of the picture plane. When the surface of the painting is looked at, it is just that: a surface. Not a metaphor of a body or a space within the picture, but an object within a world of other objects. 'What you see is what you see' said Stella. And there is a deliberate matter-of-factness about Stella's paintings from this time. The regular and relatively simple linear

patterns of his large compositions had been designed in advance, scaled-up onto the canvas with pencil, and painted-in with a decorators' brush and commercial (enamel or aluminium) paint. By 1960 he had begun to notch the canvases so that the overall shape of the work corresponded to the internal design (fig.17). Their objectness, then, was a combined product of a continuous, all-over, 'de-centred' and repetitive design, and a largely monochromatic surface. Being glossy or semi-reflective, this surface is further literalised: hard and flat; only a skin; without *interiority*. Being pulled out of the standard rectangular shape, and pushed away from the wall by the use of deep stretcher bars, the conventional idea of the painting as a transparent screen opening onto an imaginary space gives way to the idea of painting as an opaque surface occupying actual space.

This literalness was, for Stella and Judd, in contrast with the 'humanism' of European painting in which the presence of something beyond the painting was always implied within the painting. Both artists stressed the

12 *left*
Jasper Johns

Target with Four Faces
1955

Canvas, plaster and
wooden box with hinges
With box open:
85.3 × 66 × 7.6
(33¾ × 26 × 3)
The Museum of Modern
Art, New York. Gift of Mr
and Mrs Robert C. Scull

13
Robert Rauschenberg

*Untitled [Glossy Black
Painting] c.*1951

Oil and newspaper on
canvas
221 × 439.5
(87 × 171)
Courtesy
PaceWildenstein,
New York

importance of symmetry in their work as a means of dispelling the implicit anthropomorphism evident in even the most abstract of European art – be it Mondrian's or Malevich's or Kandinsky's. Such work was premised on the idea that an intuitive asymmetric balance could be achieved through the constant re-ordering of the relations between parts: 'You do something in one corner and you balance it with something in the other corner' said Stella sardonically, in the same interview. Symmetrical compositions both avoided 'balance', and helped to stress the singularity of 'the whole thing' over the idea of an art of organically related parts.

The progressive de-centring, de-humanising, and literalising of the painting surface was a hallmark of a wide range of art and critical writing of the time. The almost featureless, near monochrome, simply gridded, uniformly square, relentlessly repeated and apparently impersonal canvases of Ad Reinhardt were hugely important to the young Judd. Agnes Martin's paintings retained an autographic and expressive touch, atmospheric and allusive colour, but were nonetheless allover and centreless and influential.

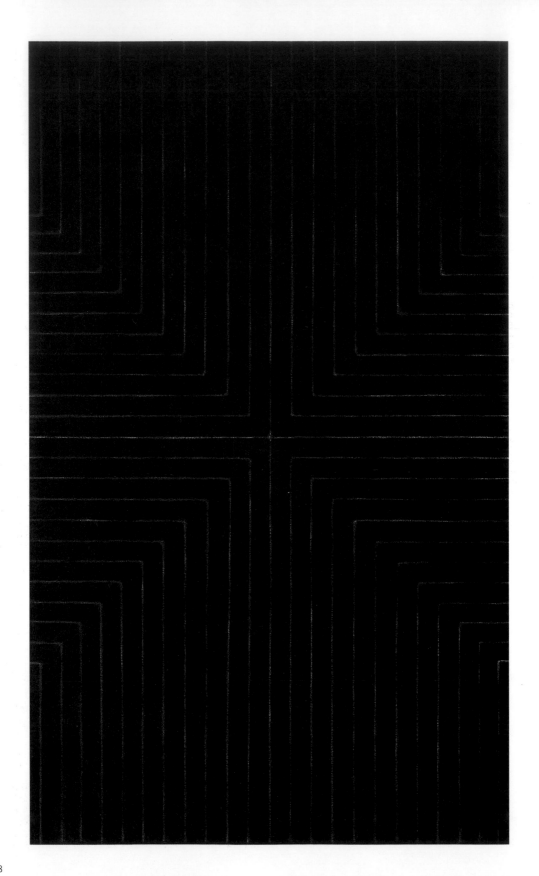

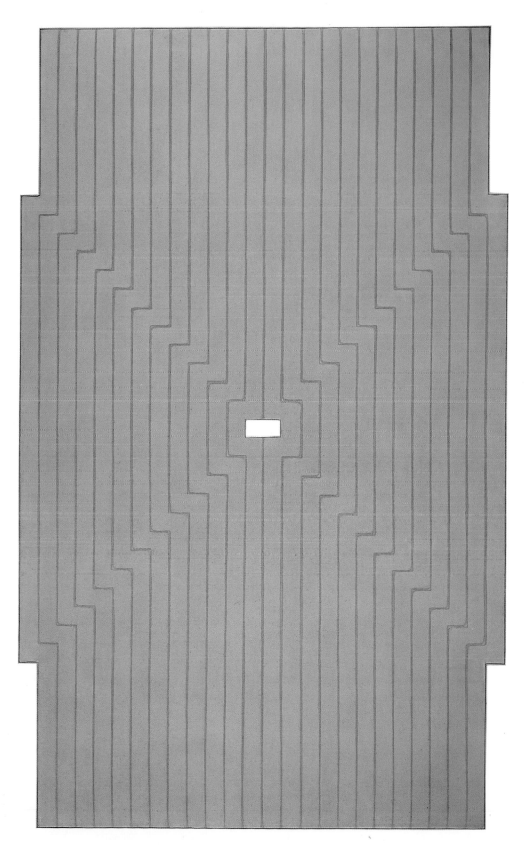

14
Frank Stella

Die Fahne Hoch!
1959

Black enamel on
canvas
308.6 × 185.4
(121½ × 73)
Whitney Museum
of American Art,
New York

15
Frank Stella

Six Mile Bottom
1960

Metallic paint on
canvas
300 × 182.2
(118 × 71¾)
Tate Gallery

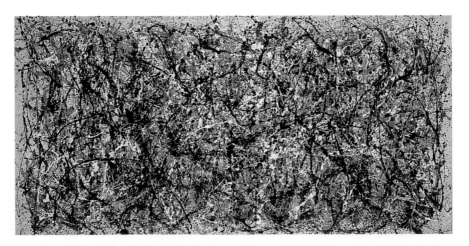

Rauschenberg and Johns had both talked of the need to eliminate hierarchy and focus in their work. 'We know of two ways to unfocus attention' wrote John Cage, the artists' mentor and collaborator, 'symmetry is one of them; the other is the over-all where each small part is a sample of what you find elsewhere'. Johns indicated his preference for 'pre-formed, conventional, depersonalised, factual, exterior elements' and Cage again stressed that 'not ideas but facts' were appropriate to an art which was simply 'a place where things are, as on a table or on a town seen from the air'. And almost any of these statements could be applied to the paintings of Andy Warhol which, from 1962, through the incorporation of multiple repeated screen-printed imagery culled from publicity stills, newspapers and advertisements, become both emphatically all-over and impersonal looking (fig.16). Greenberg, for whom none of the artists listed here held any especial interest, nonetheless also stressed the importance of the 'all-over, undifferentiated' surface of post-war painting, and seemed to be heading in a literalist direction when in 1954 he stated that 'The picture has now become an entity belonging to the same order of space as our bodies; it is no longer the vehicle of an imagined equivalent of that order. Pictorial space has lost its "inside" and become all

16
Andy Warhol

Marilyn Diptych 1962
Acrylic on canvas
205.4 × 144.8
(81 × 57)
Tate Gallery

17
Jackson Pollock

One (Number 31, 1950) 1950

Oil and enamel on canvas
269.5 × 530.8
(106 × 209¾)
The Museum of Modern Art, New York. Sidney and Harriet Janis Collection Fund (by exchange)

"outside". The spectator can no longer escape into it from the space in which he himself stands'.

If the reflections of a diverse range of artists and writers had something in common, it was because they had the same source: recognition of the towering significance of Abstract Expressionism, and the work of Pollock, Newman, Rothko and Still in particular (fig.17). Which is not to say, of course, even if they took some of the same things from this work, that they made similar things out of it. This is not the place to go into who made what of, say, Pollock's work, although the early work of Rauschenberg, Stella and Louis (fig.30) are enough to show something of the range of possibilities within painting. Rather the point to note here is the degree to which it was a tradition of painting rather than sculpture which preoccupied many of these artists and writers.

JUDD

Judd had been painting since the early 1950s (fig.18). By the early 1960s the irregular, floating, abstracted forms and landscape spaces had been replaced by broad expanses of textured oil paint (usually cadmium red light). Judd often fixed a central element, usually a 'found object' of some kind into or onto this surface (fig.19). Certainly this central element – this readymade in a monochrome – helped to literalise what might otherwise be read as a

18
Donald Judd

Untitled 1958

Oil on canvas
82.5 × 101.6
(32½ × 40)
Donald Judd Estate,
Marfa, Texas

21

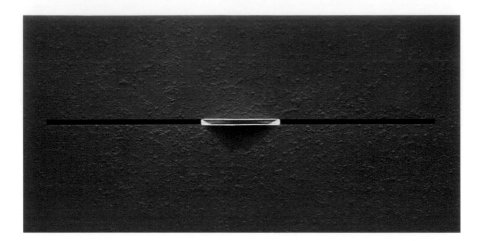

relatively naturalistic monochromatic field, but it still has the quality of an
interruption to, or a recovery from, a potential drift into a kind of optical
space. A few months later the possibility of this type of naturalism had gone,
even in work which remained wall-based and painted. *Untitled*, 1963 (fig.20)
has a similar size horizontal red-painted panel (four feet by eight feet:
standard size plywood board or shuttering), but the coloured surface is
broken up by constructed, regular grooves rather than more organic painterly
deposits. Despite the differences in materials in this work, there is now more

continuity between the painted section and the curved galvanised quadrants on either side – they appear to have been made by similar workshop processes – and the whole work reads as a single shallow tray, rather than as a painting containing some sort of shallow depression or attachment. By 1962 Judd had also begun to make his first floor-based, free-standing objects, but many of these remained as frontal and as painting-derived as his reliefs. In an interview over twenty-five years later, Judd restated that in his work of the 1960s, the significant influences remained 'Pollock and Still and Newman and Rothko'.

MORRIS

If Morris's work looks something like Judd's, his sense of history generally does not. In his 'Notes on Sculpture', Morris not only refuted the significance of painting in the genesis of 'present day sculpture', stressing instead the separateness of each domain, he stated that 'the concerns of sculpture have been for some time not only distinct but hostile to those of painting'. For Morris, the autonomous tradition of modern sculpture began with Vladimir Tatlin and the Russian Constructivists, and could only be continued if it abandoned any characteristics that could possibly be shared with painting. He listed the relief format and the use of colour in sculpture as examples of its corruption by painting. While this historical account is clearly incompatible with Judd's, there are nevertheless areas of overlap when it comes to describing what makes the new work distinctive. Morris asserted the value of forms which 'are dominated by wholeness' as opposed to those which 'tend to separate into parts', and recommended the use of 'simple forms which create strong gestalt sensations' in sculpture. Part-by-part composition and internal asymmetric balance was for Morris, as for Judd and Stella, a hangover from 'retardataire Cubist aesthetics'. But more than Judd or Stella, Morris became almost exclusively preoccupied with external relationships: those between the sculpture, the space it occupied, and the viewer. 'The better new work takes relationships out of the work and makes them a function of space, light, and the viewer's field of vision'. And this relocation of attention from the interior dynamics to the exterior relations of sculpture Morris equated with a shift from an intimate, private, mode of experience to a more public and self-conscious mode. In fact, for Morris, almost any detail, colour or surface variation in a work was at odds with the 'indivisible and indissoluble whole' and simply 'had to be rejected'.

Whereas Judd's 'Specific Objects' identified a broad trend in contemporary art and linked a lot of otherwise diverse work, 'Notes on Sculpture' principally described Morris's own work of the time, and differentiated it from that of his contemporaries. As well as criticising the use of colour and the relief format, Morris dismissed as imagistic the use of 'repetitive modular units', and linked the redundant Cubist aesthetic with 'the specific object'. Since 1963 Morris had been exhibiting the kind of work which his essays would later argue was necessary (fig.21). Made in plywood and painted a

19
Donald Judd

Untitled 1962

Oil and wax on Liquitex, sand on masonite and wood, and aluminium and oil on wood
122 × 243.8 × 19
(48 × 96 × 7½)
Donald Judd Estate, Marfa, Texas

20
Donald Judd

Untitled 1963

Oil on wood with galvanised iron and aluminium
193 × 243.8 × 29.8
(76 × 96 × 11¾)
Courtesy Paula Cooper Gallery, New York

uniform light grey (Morris did not regard grey as a colour), each of these works was based on a simple polyhedron. Some rested on the floor; one eight feet by eight feet square-shaped block, *Untitled (Slab)*, was raised by unseen supports and appeared to float just above the ground; another block, *Untitled (Cloud)*, was suspended from the ceiling; other works were braced between two walls, or between wall and floor, or leaned into the triangular space at the corner of the room. The positioning of the beam-like, slab-like, L-shape or triangular constructions clearly animated the otherwise inert forms. And, as Morris demonstrated in a group of three L-shaped works from 1965, identical forms will appear quite unalike if they rest on a different face or edge (fig.9). That is to say, a simple gestalt form is none the less modified by

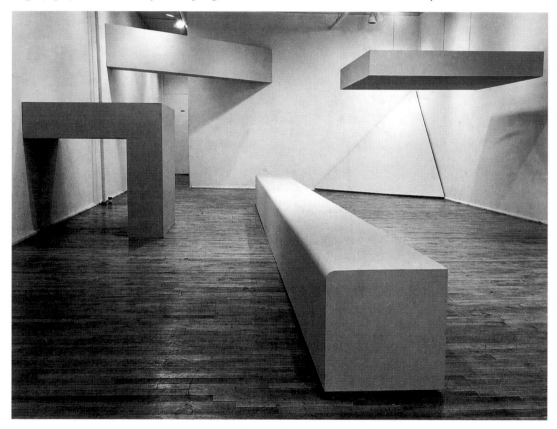

variations in the conditions of perception – an observation which reinforces Morris's argument about the triangular relationship of object–space–viewer.

This interest in the relationship between the object and the conditions of spectatorship derives in part from Morris's (and some of the other artists') interest in the writings of Maurice Merleau-Ponty, and his *Phenomenology of Perception* (1945) in particular. Cited as 'the central philosopher for Minimalist art', Merleau-Ponty is often represented as having provided the theoretical focus for much of these artists' thinking. Following Merleau-Ponty, objects and works of art were treated not as unvarying things knowable in isolation from the contingencies of setting and seeing, but as 'constantly subjected to the definition of a sited vision', to quote Rosalind Krauss. To the extent that

Minimalist works alert the viewer – through their shape, surfaces and positioning – to the contingencies of site and the variability of perspective, they begin to imply a different kind of viewer. At least, in relation to a theory which understands the perception of art as instantaneous and disembodied, this work implies a different kind of viewer: one who is embodied and whose experience exists through time and in real space. Morris, in work such as the *L-Beams*, alludes to phenomenology more directly and self-consciously than the other artists. As well as influencing his choice of shape and positioning it clearly also helped determine his decisions about the appropriate size for his work. Smallness Morris associated with the ornaments and intimacy and detail; much larger than human-scale could overwhelm the viewer. Large but

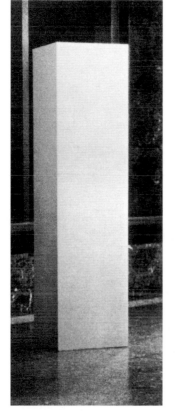

21
Robert Morris
Installation at the Green Gallery, New York, 1964

22
Robert Morris
Column 1961
Painted plywood
243.8 × 60.9 × 60.9
(96 × 24 × 24)
(Reconstruction)

not gigantic was for Morris appropriate to an externally oriented and public-type work. In this idea at least he was influenced by the older artist, writer and architect Tony Smith, whom Morris quoted at the beginning of the second part of his 'Notes on Sculpture'. But there is also something quite pragmatic about the sizes Morris used. Ninety-six inches comes up a lot in the dimensions of these works, as it does in Judd's: an eight foot square slab is two sheets of standard-size plywood.

When Judd, who between 1959 and 1965 generated income by writing reviews mainly for *Arts* magazine, first saw Morris's work in New York in 1963 he was cautious: 'The three large pieces are medium gray and completely bare. The understatement of these boxes is clear enough and potentially interesting, but there isn't, after all, much to look at. The horizontal slab suspended at eye level does work. It is a good idea.' A year later, while acknowledging the significant absence of any 'hierarchical values' in the work, he still needed 'more to think about and look at'. By early 1965 however, Judd was more convinced, if not by the look of the work, then by the 'powerful' way it occupied the space in which it was set (fig.21).

But there is something paradoxical about Morris's work. For all its stark abstractness, its lack of internal detail and its simple uniformity, it is nevertheless often both quite *pictorial* as well as illusionistic. *Untitled (Slab)* hovers. A similar form suspended from above is sub-titled *Cloud* (see fig.21). Judd's work, by contrast, was uniformly untitled from *c.*1962 onwards. Its unequivocal abstractness is not softened by imagistic titles. There again, there is significantly less internal detail in Morris's work, so an interpretative title of some kind might have been used by the artist as a form of compensation, a concession to the inexperienced viewer. In an interview in 1985, Morris talked

about the importance of Marcel Duchamp, and to some extent Johns, in his work of this time (i.e. not Abstract Expressionism and not principally painting), but in other respects the origins of the work are not so much in the tradition of Constructivist sculpture and the readymade, as in theatre and dance. Since the mid-1950s Morris had been involved with experimental dance workshops. In 1960 he joined the Judson Dance Theatre, a group which included, among others, Rauschenberg and the dancer and choreographer Yvonne Rainer; and he was familiar with the innovatory work of the choreographer Merce Cunningham and his regular collaborator, John Cage. Morris's first painted plywood work, made in 1961, was titled *Column* (fig.22). It was first shown not as a sculpture but as part of a performance for the Living Theatre in New York. During the course of the seven minute event, the column stood erect and stationary for three-and-a-half minutes at the centre of an otherwise empty stage. It then toppled over and remained horizontal and stationary for a further three-and-a-half minutes. Morris had intended to be inside the hollow form and to topple it himself; in the end it was used empty and moved with a string from the wings. *Column*, then, is at one level a kind of abstracted figure; the performance a reduction of dance to a single, elementary movement, shorn of gesture or expressiveness. In the context of a work such as this, and his other abstract but figure-implying work from the same time, works such as the *L-Beams* take on an unavoidably anthropomorphic and narrative role.

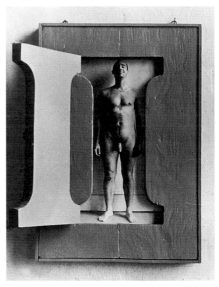

In this respect, Morris's plywood constructions represent a continuation of his earlier work which was produced out of a more direct interest in Duchamp and the iconoclasm of the international Fluxus group. Taking their lead from the work of Cage and his seminal *4'33"* – a composition in which the pianist sits inert and silent on stage in front of an unplayed piano for four and a half minutes – Fluxus 'events' were usually just that: events. Like Duchamp's readymades, Cage's music and Cunningham's dance, which refused respectively any absolute distinction between art and ordinary objects, music and ordinary sounds, and dance and ordinary movement, Fluxus events were made up of simple directives, repeated trivial actions, random occurrences, and arbitrary rules. As often as not the distinction between performer and audience was blurred (if not dissolved) as the audience *became* the performer. Morris's *Column* was originally made for a Fluxus event. A year earlier, in 1960, Morris had written a manifesto for the proposed Fluxus *An Anthology*. He discussed the idea of 'Blank Form' sculpture, and gave some examples:

1. A column with perfectly smooth, rectangular surfaces, 2 feet by 8 feet, painted gray.
2. A wall, perfectly smooth and painted gray, measuring 2 feet by 8 feet by 8 feet.
3. A cabinet with simple construction, painted gray and measuring 1 foot by 2 feet by 6 feet – a cabinet just large enough to enter.

The *I Box*, 1962 (fig.23) continues the themes of human presence, enclosure, and narrative. A small, painted object-picture (reminiscent of Johns's work from the 1950s), the cut-out 'I' sits flush with the picture surface, or may be opened by the viewer to reveal a full-length photograph of the naked artist. A number of other assembled works, such as *Box with the Sound of its own Making*, 1961 and *Card File*, 1963, are made from everyday materials and narrate their own genesis in one way or another. Some form of temporality and reference to human presence through process or performance is rarely absent from Morris's work.

ANDRE

Andre's is the only work from this 'group' which more or less unambiguously has its origins in a tradition of sculpture. During 1958 and 1959 Andre made a number of small and larger free-standing sculptures mostly from single sections of construction-grade timber (fig.24). The majority of the works from this loose group had a series of regular and repeated cuts made into the surface of the block with an electrical saw (burns from the saw-blade are sometimes visible). Unlike the early work of Judd or Morris, Andre's was neither assembled from parts nor painted. The strongest reference in this work is to Constantin Brancusi, to his *Endless Column* and his rougher wooden sculptures and pedestals in particular (figs.25, 26). Uniquely among sculptors during the first half of the twentieth century, Brancusi had made work based on linear assemblies of repeated standard units. Andre's admiration for this aspect of Brancusi's oeuvre, and for his use of combinations of found and unaltered sections of material in general, is well documented. Unlike Brancusi, Andre made these early experimental works — now mostly either lost or destroyed — from single blocks of material. By 1959, however, he had begun to assemble work from preformed units. *Cedar Piece* (fig.27) was the largest, most ambitious and most complex of these. While Andre was clearly preoccupied with questions of sculpture — in his recorded conversations with his contemporary, the photographer and film-maker Hollis Frampton, he regularly refers to Rodin as well as Brancusi, Picasso and Duchamp, Smith and Chamberlain, Oldenberg and Johns — painting was not entirely absent from the picture. Literally: some of Stella's paintings of the period form the backdrop to Frampton's photographs of Andre's sculptures, which had been made in the painter's studio. Andre had known Stella since 1952, and had been impressed with the way he made paintings 'by combining identical, discrete units'. *Cedar Piece* is clearly quite like Stella's work in its repeated use of one basic unit, and in its stepped diagonal pattern.

By 1960 Andre had begun a series of drawings and sculptures which kept to the same principles he admired in Brancusi's and Stella's work, but which radically simplified his own compositions and working methods. The basic unit of his *Element Series* (fig.28) was a 1:3 ratio beam. Each sculpture was to be — Andre could not afford to make this series until some years later — a

23
Robert Morris
I-Box 1962 (open)
Mixed media
45.7 × 30.4 × 5
(18 × 12 × 2)
Private Collection

combination of between two and twelve elements laid horizontally or vertically over one another. The only exception, a single standing element, is obviously reminiscent of Morris's *Column* of the same year. The point here is not how alike they look – as shapes – but how *unalike* they are in most other respects. Unalike in the use of materials, volume, mass, weight, size, surface, technology, history and presentation. Alike perhaps in a general orientation towards simple and unadorned form, in a belief that sculpture could be made by stripping away inessential detail, and in abandoning certain kinds of illusionistic reference. And alike too in a recognition that a shift in emphasis was taking place from the idea of space-within-a-work to the idea of a work-within-space. As Andre noted: 'Up to a certain point I was cutting into

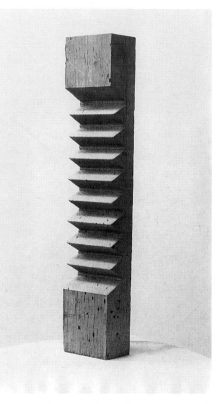

things. Then I realised that the thing I was cutting was the cut. Rather than cut into the material, I now use the material as the cut in space'.

If work such as Andre's comes out of a tradition of sculpture more than painting, can it be made to fit any more easily within a Modernist framework of sculptural development? In his essay 'The New Sculpture' Greenberg had in 1958 presented an extraordinarily concise summary of the development of a range of twentieth-century sculpture. Citing its origins in Cubist painting and collage, he linked the 1940s and 1950s linear welded steel work of artists such as David Smith with Picasso's early experimental constructions of 1913. This sculpture avoided the tactile illusionism of nineteenth-century work (that is, the illusion that one material, say, wood or stone, would feel like another, say, skin or cloth) in the same way that painting did away with spatial illusionism. 'The new sculpture', Greenberg went on, 'tends to abandon stone, bronze and clay for industrial materials like iron, steel, alloys, glass, plastics, celluloid, etc., which are worked with the blacksmith's, the welder's or even the carpenter's tools ... The distinction between carving and modelling becomes irrelevant: a work or its parts can be cast, wrought, cut or simply put together; it is not so much sculpted as constructed, built, assembled, arranged'. Andre uses modern materials or materials which have been processed by industrial means; from 1960 those materials are 'simply put together'. And his work is emphatically anti-illusionistic; perhaps more so than any other artist working at the time. Many artists – David Smith for example – had used modern materials and techniques to generate not tactile illusions, but illusions of weightlessness, in a kind of optical sculpture of floating lines and planes. Andre avoids any

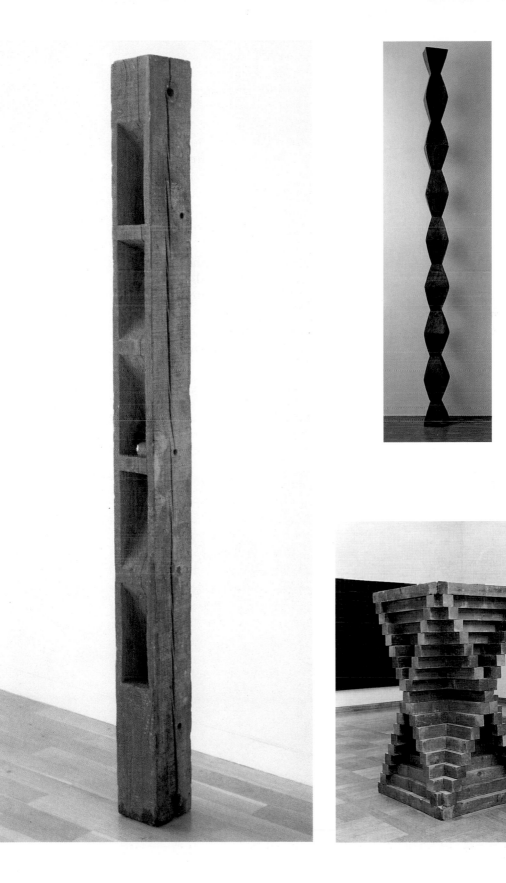

gravity-defying effects by choosing not to bind, glue, weld, bolt, screw or in any other way hold the elements together. It is a sculpture of placement.

Greenberg's historical account seems to invite work like Andre's to come into existence; it certainly does not say anything which would exclude it, or Judd's, Morris's, Flavin's or LeWitt's. Nevertheless, Greenberg never accepted this work as legitimate. In 'Recentness of Sculpture' in 1967, he stated that at best it was like 'good design'; at worst it was just 'far-out'; and in that it was just the same as Pop and Op and Kinetic and all other forms of 'Novelty Art'. His main objection was that this was 'too much a feat of ideation, and not enough anything else'. That is to say, the work appeared to have been conceived and then executed according to a plan, instead of being 'felt and discovered'. If a narrative of struggle and improvisation represented in visible form are a precondition of authentic art, then this work might well fail to make the mark. But perhaps a certain felt-and-discovered look had become conventionalised and mannered, that is to say *in*authentic, for this generation of artists. And perhaps a rigorously anti-pictorial and anti-illusionistic sculpture was bound sooner or later to turn against these devices. In which case Greenberg's objections might refer untimately less to a failure in the work than to a failure of nerve on his part, to a backing down from the implications of his own thinking.

28
Carl Andre

Page from drawing book of *Element Series* 1960

Pencil on paper
Courtesy Paula Cooper Gallery, New York

29
Dan Flavin

The diagonal of May 25, 1963 (to Robert Rosenblum) 1963

Fluorescent light and fittings
243.8 (96) long
The Pace Gallery, New York

Once established, the grammar of Andre's sculpture has remained in place and largely unchanged. Like Andre, both Flavin and LeWitt established a certain pattern of work during the early 1960s, and have remained close to it since. In Judd's work, by contrast, there is no such easily identifiable starting point; rather it emerged bit-by-bit out of painting. Morris's Minimal work has a definite starting point, but it also has an equally definite stopping point. It marked an episode in a diverse and eclectic body of work. Both Flavin's and LeWitt's three-dimensional work is narrower in range than Judd's or Andre's. For Flavin a single material and for LeWitt a particular format encompasses the large majority of their work.

FLAVIN

Dan Flavin's signature work began in 1963 (fig.29). In 1964, Judd commented
in a review of the group exhibition *Black, White and Gray*: 'A single daylight-
white tube has been placed at a diagonal on approximately an eleven-by-
eleven wall . . . It makes an intelligible area of the whole wall. There is some
relation to the diagonals of [Robert] Morris and [Morris] Louis. The tube is
a very different white, in colour and texture, from the painted white of the

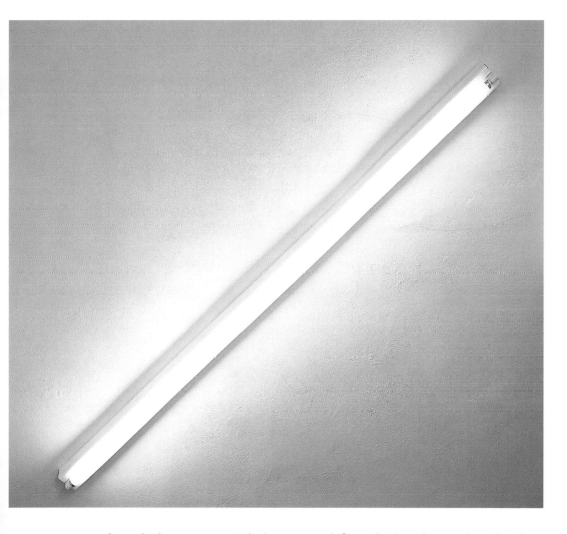

box which supports it. The box casts a definite shadow along its length. The
light is cast widely on the wall. The light is an industrial object, and familiar;
it is a means new to art'.

For obvious reasons, Flavin's work is harder to see in reproduction than
most. To see a Flavin is to see its effect on the space it occupies – more directly
than in either Morris's or Andre's work. The objectness of a Flavin is evident
and structural and important – the supports for the fluorescent tubes are
never hidden, sometimes face the viewer, and are always arranged into a

specific shape – but the experience of the work is also strongly optical. Light is diffused into the surrounding space or cast onto nearby surfaces. Different coloured lights in the same work mix in space to produce new colours. This led Judd to characterise aspects of Flavin's work in terms of painting. In particular he likened it to the late works of Morris Louis, which were made by pouring liquid paint in vertical stripes onto, or rather into, raw, unprimed canvas (fig.30). Flavin's work is literally much brighter than any painting could be, but Louis's paintings almost seem brighter because they are so much more brilliant than just about any other painting. The colour of a Louis, being in the weave of the canvas, appears, a little like a Flavin, also to emanate from the material.

There are other reasons for likening Flavin's work to painting. One is that the work, in being attached to the wall, occupies the space of painting. Another is that Flavin not only takes over the place of painting, but sometimes also its shape (fig.31). This frame-like composition relates to some of Flavin's earlier three-dimensional work, a series of wall-mounted constructions in which a central, painted, box-shape has one or more fluorescent or incandescent or flashing lights attached to some or all of its edges (figs.32, 33). They are strange works, and hard to place. In each of the eight works in this series – titled *Icons* – most of the incident takes place not so much in the work but around its edges. For Judd they were 'blunt' and 'awkward' and

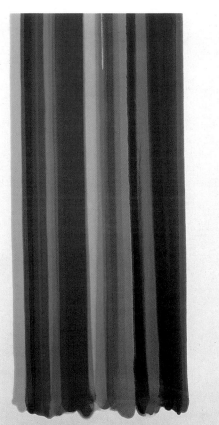

30
Morris Louis

Third Element 1962

Synthetic polymer on unprimed canvas
207.5 × 129.5
(85¾ × 51)
The Museum of Modern Art, New York.
Blanchette Rockefeller Fund

31
Dan Flavin

Ursula's One and Two Picture 1/3 1964

Fluorescent light and fittings of various dimensions
Solomon R. Guggenheim Museum, New York. Panza Collection

'interesting', which seems like fair comment. But reference to painting alone is clearly not enough. Flavin's use of industrial products means they have one foot firmly set in the readymade. Flavin himself noted in 1965 that what he termed his 'dramatic decoration' had been 'founded in the young tradition of a plastic revolution which gripped Russian art only forty years ago'. 'My joy', he continued, 'is to try to build from that "incomplete" experience as I see fit'. This admiration for Constructivist work of the first quarter of the century is indicated most literally in some of the titles of Flavin's works (e.g. fig.3). It is possible also that Flavin's decision sometimes to position work in the corner of a room began as an acknowledgement of Tatlin's remarkable early *Counter*

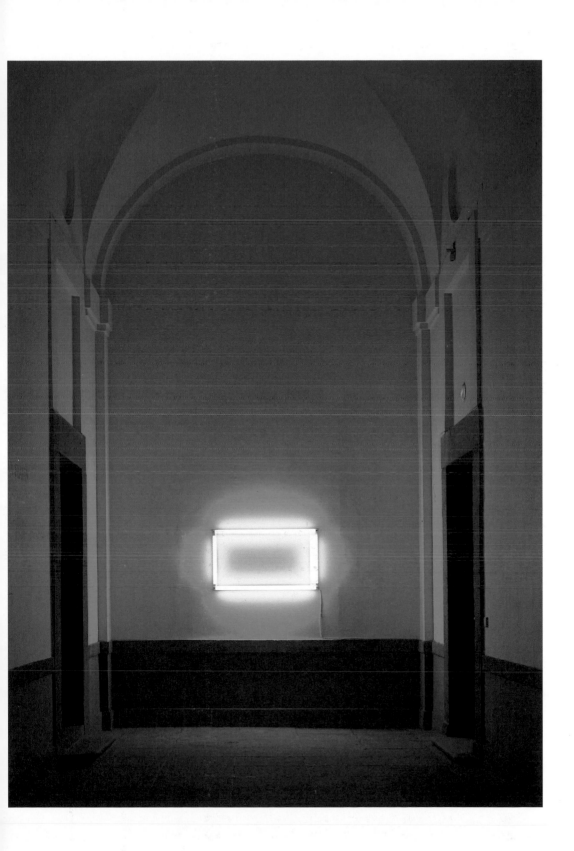

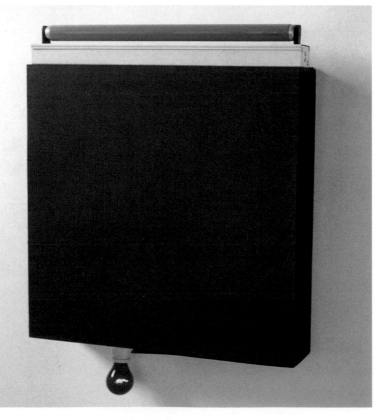

32
Dan Flavin

Icon IV (Ireland dying)
(to Louis Sullivan)
1962–3

Oil on masonite and
mixed media
64 × 64 × 26
(25 × 25 × 10¼)
Donald Judd Estate,
Marfa, Texas

33
Dan Flavin

Icon III 1962

Oil on masonite and
mixed media
64 × 64 × 26
(25 × 25 × 10¼)
Donald Judd Estate,
Marfa, Texas

34 *right*
Vladimir Tatlin

Corner Relief 1915

Wood, iron and wire
78.5 × 80 × 70
(31 × 31½ × 27½)
(reconstruction by
Martyn Chalk)
Courtesy Annely Juda
Fine Art, London

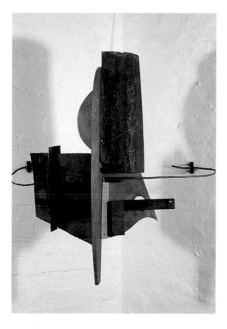

Reliefs (fig.34). These works are far more literal than most of Picasso's constructions of about the same time. Everyday materials and undisguised objects are wired and stuck and screwed together. A set-square forms an angled plane in front of a painter's palette – symbolising perhaps Tatlin's belief that engineering would eclipse craft in the new art of the twentieth century. If Flavin had rather more room to realise this idea in post-war America than Tatlin had in post-revolutionary Russia, it was not so much the result of a more open cultural climate (on the contrary perhaps), but simply because by then the materials for an industrial art had, as Judd said, become 'familiar'.

LeWitt

Sol LeWitt made his first modular cube structure in 1965 (fig.35). Dissatisfied with the finish of an earlier enclosed structure, he commented: 'I decided to remove the skin altogether and reveal the structure. Then it became necessary to plan the skeleton so that the parts had some consistency. Equal, square modules were used to build the structures. In order to emphasise the linear and skeletal nature, they were painted black'. LeWitt wanted the surface to look 'hard and industrial'; by the end of that year the structures were painted white to mitigate the 'expressiveness of the earlier black pieces'.

The relationship of LeWitt's work to painting and sculpture is ambiguous. A number of constructed works from 1962–4 involved three-dimensional projections from within a flat, square, painted, picture-frame format (fig.36). Others had openings which revealed or promised to reveal an interior space; and some had both projecting and receding sections. Here again the optical space of painting is turned inside out or literalised, but rather more in the way of Johns's compartment paintings than Stella's flat and shaped canvases. However, in these and later works LeWitt does not exclude or abolish all reference to interiority: the element protruding from the centre of *Wall Structure, White* appears to come from behind the picture plane, and a hole at the centre of the protrusion seems to invite the viewer to peer into an interior space. Several wall-based, box-like works made by LeWitt during this time include one or more eye-level peep-holes which partially reveal an internal space containing another element of some kind: a lightbulb, a work by another artist, a series of photographs of a naked woman. In fact nearly all

LeWitt's early structures contain some sort of partially concealed space-within-a-space. When in 1965 LeWitt stripped away the skin from his structures, he didn't do away with internal space in favour of pure exteriority, so much as abolish the distinction between inside and out, by recourse to a form of linearism.

The open modular cube structures are at once more and less sculptural than the earlier work: they literally occupy more space than a Flavin or many an Andre or a Judd, but they have no real volume or mass. In their linearity they suggest a relationship not so much with painting as with drawing. In a number of ways drawing is more important to LeWitt's art than to almost

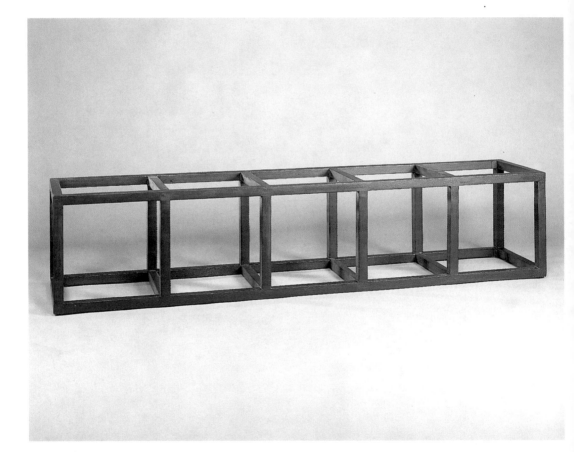

any other painting or sculpture of the time. And not simply in the sense that the structures are often linear; drawing is a far closer relative than that. Much of LeWitt's three-dimensional work originates in two-dimensions; the structures are preceded by working drawings, and drawings may also succeed a structure. There are practical reasons for this basis in drawing. Since c.1965 LeWitt has had his structures executed by professional wood or metal workers. (So has Judd; and Morris's work during this time was also made professionally. The situation is different for Andre who does not have his materials worked in the same way, and for Flavin who acquires an assembly of components before having them installed by technicians.) A drawing or

diagram remains the most efficient way of representing an object to another person. But the relationship between drawing and three-dimensional work is more than a practical arrangement; it is also part of the content of LeWitt's work. More than the other artists, LeWitt has thematised this relationship between two and three dimensions, between conception and execution, between the idea of the work and its physical form. And he has often done this by divorcing one from the other.

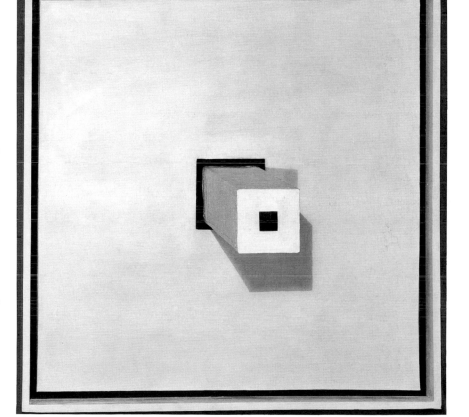

35
Sol LeWitt

Floor Structure Black
1965

Painted wood
47 × 45.7 × 208.3
(18½ × 18 × 82)
National Gallery of Art,
Washington

36
Sol LeWitt

Wall Structure, White
1962

Oil on canvas and
painted wood
114.3 × 113 × 49.5
(45 × 44½ × 19½)
Wadsworth Atheneum,
Hartford, Connecticut.
The LeWitt Collection

2

OF OBJECTS AND SUBJECTS

LeWitt's early structures are linear and transparent; Morris's sculptures are closed, hollow volumes; Andre's are sections of raw material, solid but sometimes flat and without volume; Judd's three-dimensional work is usually open, often in relief, sometimes painted or using coloured materials, sometimes not, sometimes a combination of both; Flavin's 'proposals' are coloured but not painted; they are specific objects but with variable limits. The experience of any of these works is bound to be as different as the materials they are made from.

The materials of sculpture are a part of its subject. Since Picasso and Tatlin assembled small reliefs from bits of wood, cardboard, string, wire and various objects, artists working in three dimensions, or in literal rather than illusionistic space, have had a world, or more of a world, to work with. Modernity need no longer be depicted; it can be sampled from the developments of industry or the debris of everyday life. For Judd, Flavin's fluorescent light was 'a means new to art' which could now 'be made of any number of new objects, materials and techniques'. LeWitt wanted his work to appear 'hard and industrial'. Andre has often stressed how his experience working on the Pennsylvania Railroad had 'a strong influence' on the materials, scale and formats of his sculpture. In part III of 'Notes on Sculpture' Morris insisted that 'the new three-dimensional work has grasped the cultural infrastructure of [the process of] forming itself which ... culminates in the technology of industrial production'. In this kind of work built from the structural and industrial materials of modern urban life, terms

like 'abstract' and 'figurative' begin to lose their meaning. A row of steel boxes is no less of or about its times than a topical pictorial tableau: on the contrary, perhaps.

But modern materials are only half the story; the *deployment* of those materials is the other half. Hard and industrial materials do not necessarily produce a 'hard and industrial' look. To achieve this look LeWitt needed to get rid of certain kinds of finish (rather than certain materials) and, in particular, certain types of composition. 'Hard and industrial' is more than literal; it is also a range of expectations and associations. Among these associations are the mechanically produced as opposed to the handmade, and the standardised and repeatable as opposed to the unique. LeWitt's early open cube structure is both handmade and unique, but it none the less looks as if it might have been made by machine as one of a potentially limitless number. It has a uniform rather than an 'expressive' surface; its composition is modular and thus repetitive.

For Morris it was not just new materials or the 'non-hierarchic, non-compositional structuring' which made this work modern, although this was clearly important; it was the application of the concept of 'forming'. Morris described the cube or rectangular block, and the right-angle grid, as the 'morpheme' (basic unit of language) and 'syntax' central to the 'cultural premise of forming', that is, to a culture where things are assembled (formed) from synthetic materials rather than grown or carved or modelled. The parts-to-whole relationship in this brick-and-grid system are more simple and more extendible than any other compositional form. The grid preserves the wholeness and morphological consistency of the basic unit. Work which has been 'formed by clear decision rather than groping craft' has 'the feel and look of openness, extendibility, accessibility, publicness, repeatability, equanimity, directness (and) immediacy'.

MORRIS

Robert Morris produced a number of four-part sculptures during 1965 and 1966 using multiple, separate, identical, regular, rectangular, cubic, or slightly off-cubic elements. Similar in appearance to the plywood works, these were 'formed' in fibreglass, and invite, or taunt, the viewer to compose the (seen) units into a single 'whole' (known) form (fig.37). Shape in these works is both a given of the individual units and something implied in the relations between the units. The related mirrored cubes (fig.10) also enact a play-off between observation and expectation as the gestalt form is swamped (or is it?) by the contingencies of setting and the phenomenology of viewing. Here more than anywhere else perhaps, Morris takes 'the relationships out of the work and makes them a function of space, light and the viewer's field of vision'.

Implicit in the idea of the module is the possibility of variable configuration. A work in which the units are simply positioned rather than

fixed in place always carries with it the idea that they might be repositioned. Morris combined the ideas of modular permutation and provisional setting in a group of works from 1965 to 1967. Like the earlier units, *Untitled (Stadium)*, 1967, was made in smooth-surfaced grey fibreglass, but consisted of two different elements, a triangular side section and a ninety-degree curved corner section. Either unit could be joined with any other to produce a wide number of possible variations. By reconfiguring the units during each successive day of the exhibition, Morris constantly renewed the overall shape (fig.38). Thus shape is brought into line as one variable among the others of space and perception. But in the process, rather different demands are made of the viewer. The relationships between constancy and variability are given a temporal dimension; memory (of earlier permutations) and anticipation (of future possibilities) become a part of the conditions of spectatorship. By involving the active participation of the artist in the manipulation of the work during the exhibition, and in so acquiring a temporal narrative component, a work like *Stadium* also re-enacts something of Morris's earlier performance-based work.

If shape, variable or fixed, takes precedent over materiality in work such as *Column*, *L-Beams*, and *Stadium*, this begins to change for Morris after the mid-1960s. In a number of modular works made during 1966 and 1967 the material begins to determine the character of the object to a much greater extent than before. But for Morris this emphasis on the intrinsic properties of materials and their forming processes soon led him away from anything that could be classed as Minimal, and towards another more process-oriented type of work 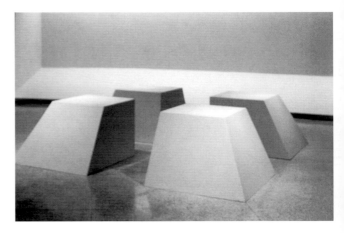 which he termed 'anti-form'. *Untitled (Tangle)*, from 1967–8 (fig.39), is one of a number of works formed by dropping strips of half-inch thick industrial felt onto a studio or gallery floor. Like the painting of Pollock or Louis, the composition results from a process involving an action (spattering, pouring, or dropping) and a non-rigid material (fluid paint or soft felt). Like a performance, this kind of work has no fixed form but rather a series of instances. For Morris the aim was to move 'beyond objects'; in the process he recapitulated something of the Fluxus task-oriented event and the Cage-ian aesthetic of randomness. It is also the first time Morris himself associated his work with painting rather than sculpture. The anti-form work of Morris was varied and highly influential; his essays from 1968–70 identify a range of contemporary artists – Robert Smithson, Richard Serra, Eva Hesse and others, as well as older artists such as Oldenberg – involved in similar post-object process-based work; but all of this is, unfortunately, beyond the scope of the present essay.

37 *left*
Robert Morris

Untitled (Battered Cubes) 1965

Painted plywood
(Destroyed)

38
Robert Morris

Drawing for *Untitled (Stadium)* 1976

39
Robert Morris

Untitled (Tangle) 1967–8

254 pieces of felt
Dimensions vary
National Gallery of
Canada, Ottawa

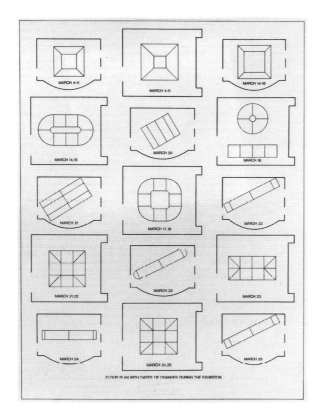

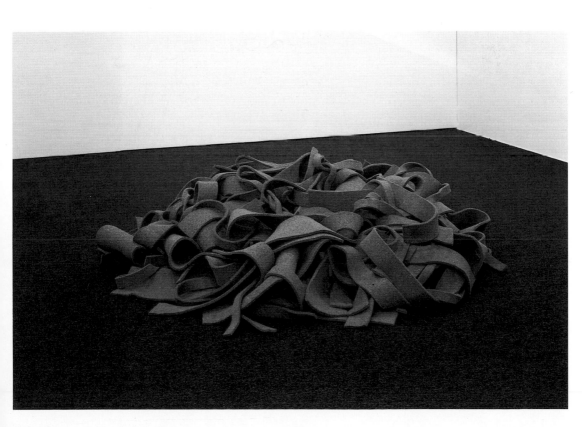

JUDD

Donald Judd's properly modular compositions begin around 1966. During 1963–4 his free-standing work is usually assembled into a single regular or irregular form, its components homogenised by a uniform coat of oil paint (fig.40). In a number of works which begin to imply the serial arrangement of independent units, in particular the horizontal 'progressions' from 1964–5, the units are physically linked in some way, often by a length of tubing running along the top (fig.41). Being made in aluminium, brass, galvanised iron or steel (rather than wood), and finished with enamel paint or lacquer (rather than oil paint), this work is both more regular and more industrial than the earlier reliefs or objects. For Robert Smithson this combination of industrial materials and sharp, highly idiosyncratic colour, gave the work an

40 *left*
Donald Judd

Untitled 1963

Oil on wood and enamel on aluminium
183.5 × 264.2 × 124.5
(72¼ × 104 × 49)
Donald Judd Estate, Marfa, Texas

41 *above right*
Donald Judd

Untitled 1966

Galvanised iron and painted aluminium
101.6 × 482.6 × 101.6
(40 × 190 × 40)
Norton Simon Museum, Pasadena. Gift of Mr and Mrs Robert A. Rowan

42 *below right*
Donald Judd

Untitled 1966

Painted steel
Overall: 121.9 × 304.8 × 304.8 (48 × 120 × 120)
Whitney Museum of American Art, New York. Gift of Howard and Jean Lipman

'uncanny materiality'. If a breakthrough occurred in Judd's relatively gradual development, then it was in 1966 with the first of his trademark 'stacks' (see fig.5). In these works, each unit is identical, with identical intervals between each unit, and each interval the same dimensions as each unit. For the first time in Judd's work the physical linkage between parts has been dropped. During the same year a floor-based equivalent of the wall-based work, made from standard section steel channel, used essentially the same compositional devices of repetition and interval (fig.42). Unlike Morris's modular permutations, Judd's positioning is a given of the work. Most of the variation takes place in the selection of material, unit profile, overall shape, and colour; that is in those areas where variation had been eliminated by Morris in his work before 1966.

For someone who put such store in the idea of the single object

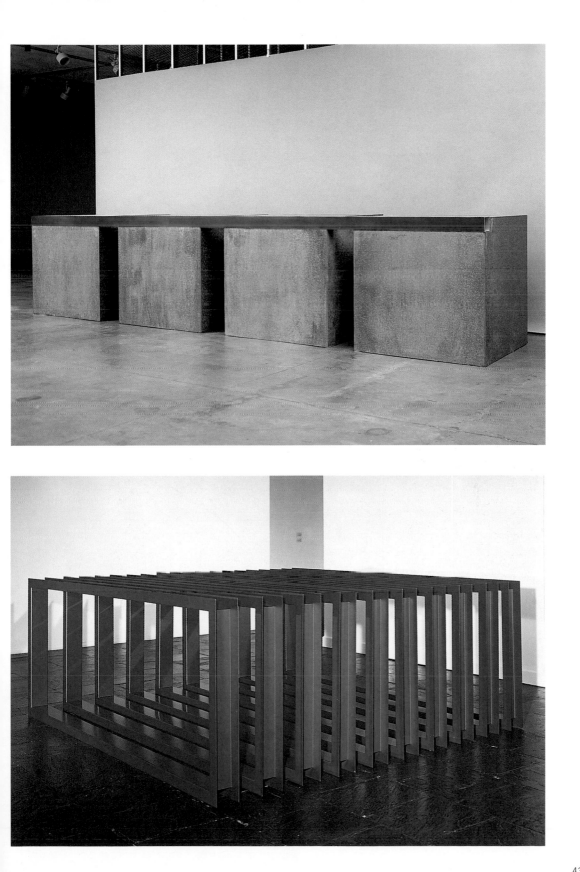

experienced as a whole, Judd made surprisingly few, if any, single, whole objects. Even his simpler cube or rectangular box works (e.g. fig.6) tend to be made of more than one material and more than one colour. But to *experience* something as singular is not necessarily the same as it *being* singular. Morris noted the impossibility of an object with only one aspect. Judd's work is always assembled from parts, but insofar as that assembly has no centre, no hierarchy, and no dynamic tension, there is (for Judd) no compromise of the experienced wholeness. Wholeness is not a literal property of Judd's work. The volumes of his three-dimensional work have no mass. Rather they are defined by assembled planes of relatively thin material which mark out, rather than displace space. Unlike Morris's slabs, beams and cubes, Judd's rectangular volumes are rarely closed on all sides. Later 'stacks', horizontal wall-based rows, and single free-standing 'boxes' often incorporate coloured acrylic sheet in the upper and lower or two side faces, making them translucent: simultaneously open and closed. Most other work is open on one or two sides. The enclosed box or cube seemed to offer Morris a precise

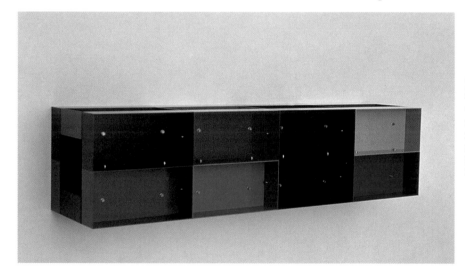

43
Donald Judd
Untitled 1985
Painted aluminium
30 × 120 × 30
(11¾ × 47¼ × 11¾)
Donald Judd Estate,
Marfa, Texas

solution to the messy problem of Cubist fragmentation. For Judd the solution did not come so quickly or all at once. The problem perhaps with the cube, was that it remained only a theoretical solution to an experienced aesthetic problem. Judd's work is empirical to the last; any solution has to be found in experience rather than just formed in thought. Equally, any solution is always specific: *this* material, *this* colour, *this* arrangement; whereas for Morris, things tend more to the general or the non-specific. Furthermore, a hollow form such as Morris's cubes or a solid cube such as Tony Smith's *Die*, 1962 (Paula Cooper Gallery, New York) might not so much supersede Cubist part-by-part-ism as revive the corpse of monolithic or cast sculpture which Cubism itself had killed-off fifty years before.

Nearly all of Judd's huge output of three-dimensional work from 1966 to his death in 1994 was based on the same principles: open-box structure, flat planes of material, repeated assembled units, inherent or applied colour. Rather than settle for a single material, or shape, or composition, or colour,

Judd's work involved a constant reordering of these variables. To what end? Only, perhaps, to find out what x material would look like next to y colour in z configuration. And in finding this out, to learn more about materials and space and colour. But in Judd's case, the process of learning through example never seems to lead inductively to the formulation of general rules or principles. Each work is an 'object' rather than a sculpture, but equally it is also 'specific' rather than general. There is only ever 'one thing after another': endless examples, but no models. A group of works from the mid-1980s exemplify much of what has just been said (fig.43). This work is wall-based but three-dimensional; assembled from identical or compatible units of sheet-metal formed into open, shallow trays. Each unit is industrially spray-painted, and each colour selected from one of the vast commercially available ranges. The vivid colours, together with their wall-setting, suggests a kind of extruded painting. But at the same time there is an insistent physicality in these works which belongs more to sculpture. That said, these are, to a greater extent than any earlier work, experiments in colour and colour combinations. There is no obvious pattern or formula in Judd's colour arrangements. Rather than use the traditional artists' colour circle as an organising principle, they are exercises in serialism. Judd's final essay, 'Some Aspects of Colour in General and Red and Black in Particular', published posthumously in *Artforum* in 1994, was largely a discussion of colour. He argued that after the 1950s, 'colour to continue had to occur in space', because only then could 'all colours be present at once'. That is to say, in a painting colours will almost always tend to advance or recede when placed next to each other. But by physically bolting swatches of colour together, they are both literally and optically held in the same space. By selecting colours from a sample book, Judd was also able to avoid the hierarchy of colour implicit in the colour-circle, with its divisions into primaries, secondaries and tertiaries. The aim, it seems, was to explore colour in a purely empirical way, without recourse to conventionalised ordering systems, in a way which 'should be intelligent without being ordered'.

LeWitt

Sol LeWitt's open modular cubes are, in one respect at least, the most 'standardised' three-dimensional work of the time. Once the ratio of the width of the bars to the space they describe was set at 1:8.5, he has never altered this relationship. Surface colour also remains a constant. LeWitt has his structures made in aluminium and in steel as well as in wood; but unlike, say, Andre — for whom to change the material is entirely to change the work — the difference between a metal or a timber open modular cube carries no real significance. Scale is a variable for LeWitt, as is positioning — most works are floor-based, a number of early pieces were wall-based and some have been suspended from the ceiling — but the most common variation is repetitive extension (see e.g. fig.8).

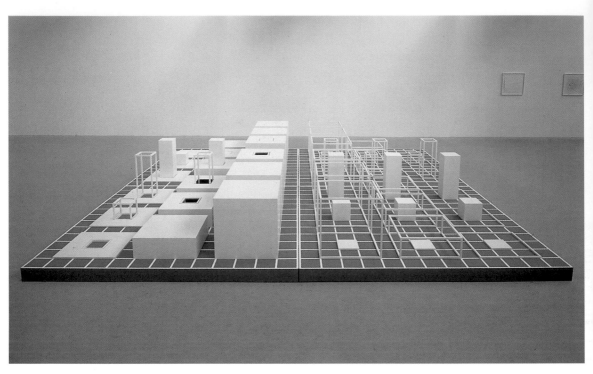

The openness of a LeWitt modular cube gives its conceptual simplicity a high level of perceptual complication. The axis between knowing and seeing is given a different centre than in Morris's work. The cube is repeated to the point of dissolving rather than re-forming into a greater whole. In Morris's enclosed shapes, object and space are distinct elements; in LeWitt's structures space is in the object as much as the object is in space. Whereas Judd's repetition is usually in clear linear series ('one thing after another'), LeWitt extends the grid format in three dimensions, neither evenly nor equally. When seriality is employed by LeWitt it is as much a generative system as a spatial arrangement. *Serial Project I (A,B,C,D)* (fig.44) is based on a 26 × 26 unit grid divided into four parts (A, B, C, D) and two basic forms (measuring 1 × 1 or 3 × 3 units on the grid), each of which has three possible heights (0, 1 or 3 units) and two possible states (open or closed). The various permutations are most easily shown in a diagram:

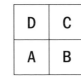

| closed inside
closed outside | D | C | open inside
open outside |
| open inside
closed outside | A | B | closed inside
open outside |

Once again, the system is really very simple, and relatively easily *stated*; but it is very difficult to *see*. Difficult to see both because the sheer accumulation of lines and planes tends to mesh together the formally distinct elements, and

44
Sol LeWitt

Serial Project I (A,B,C,D) 1966

Stove enamel on aluminium
83 × 576 × 576
(33 × 227 × 227)
Saatchi Collection, London

45
Sol LeWitt

Variations of Incomplete Open Cubes 1974

Installation including: 122 painted wood sculptures
Each: 20.3 × 20.3 × 20.3 (8 × 8 × 8)
131 frames, photographs and drawings
Each: 66 × 35.5 (26 × 14)
Collection of Jeffrey Deitch

because the use of closed forms means that some smaller elements become hidden inside larger ones (as had happened in a different way in his earlier work). The viewer has to complete the system in his or her mind; and it is only the progression of the system that tells him or her that the large $(3 \times 3 \times 3)$ cubes 'must' contain smaller elements. The completion of the series thus relies on the viewer's recognition of a certain logic, and a certain amount of trust. This work and others related to it (e.g. fig.45) are 'whole' only in that they exhaust a predetermined system of alternatives. They are hard to *see* in the terms characterised by Judd or Morris as single things. Rather, to experience the work is to become involved with or overwhelmed by a proliferation of relations-between-parts. But these relations are not balanced so much as catalogued, not intuitive so much as logical, and in some cases not seen so much as implied.

The gap between the known and the experienced seems always to have interested LeWitt. During the later 1960s he developed systematic means for ensuring he could not know from the concept of the work what the resulting structure would be like. He also stressed that 'what the work looks like isn't too important ... It is the process of conception and realisation with which the artist is concerned'. In 1967 LeWitt coined the term 'Conceptual Art'. It is a label usually associated with forms of textual or 'dematerialised' work, but LeWitt's structures are no less an art of conception. Which is not to say that the perceptual experience of a LeWitt structure is irrelevant or uninteresting. What is striking in many cases is the level of perceptual

complexity which arises out of a simple set of rules. Shadows cast by one bar over another in a modular open cube soften and scramble the work's strict geometry. Square and hexagonal channels appear at points to cut diagonal shafts into the structure, then break up and re-emerge at other points. To conceive the work and to see it are two quite different things, as different as 'the known constant and the experienced variable' of Morris's 'gestalt' shapes. But LeWitt's work is 'conceptual' in one sense which makes it unlike the work of his contemporaries: the starting concept is also in many cases a text.

A grid-like compositional structure is common to much of the work made by Morris, LeWitt and Andre, and some of the work made by Judd and Flavin. But LeWitt is the only artist who uses an actual drawn grid as a support or framing device for his three-dimensional work. And because of its location within an overall flat grid, the work also appears to have risen out of two dimensions into three. In this (and in the use of closed forms) works like *Serial Project I (A,B,C,D)* begin to look like LeWitt's 1962 wall structures (see

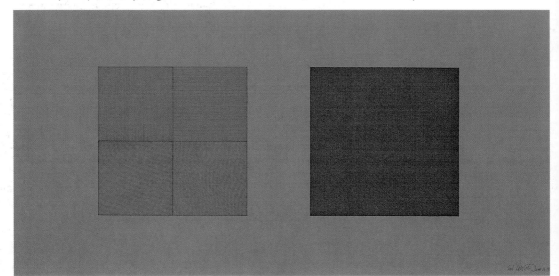

fig.36) turned through ninety degrees. This pull between different dimensions is peculiar to LeWitt's work, and may be something like a constant in it. The later *Incomplete Open Cubes*, 1974 (fig.45) is, in part, 122 structures – all the permutations of three-sided to eleven-sided cubes. And, as before but more so, the quantity of vertical and horizontal lines produced by the plan also becomes a thicket which makes the plan all but indecipherable. The regular grid gives some order to the apparent chaos, but also returns it to two dimensions by framing it. This return is consolidated on the two walls which surround the structures, as the work also consists of 122 framed drawings and photographs. *Incomplete Open Cubes* thus exists in three forms: drawing, structure, photograph – and a fourth, the title and subtitles of the piece: the text without which the concept would remain opaque. Logically the text precedes the drawings which precede the structures which must themselves precede the photographs. Thus the work begins in two dimensions, is pulled into three before being snapped (literally) back into two.

The importance of drawing to LeWitt's work is consolidated in a series of highly original works begun in 1968: the 'wall drawings'. The earliest of these were derived from a group of serial drawings elaborated by LeWitt between 1968 and 1969. Each of the serial drawings was composed of four types of lines – vertical, horizontal, diagonal right to left, diagonal left to right – drawn within a square divided in quarters (fig.46). Variations of position within the square and superimposition of two or more types of line produced 192 permutations. Executed at the Paula Cooper Gallery in New York, the first wall drawing was drawn with a very hard pencil in two four-

PLAN FOR WALL DRAWING / PAULA COOPER GALLERY / MAY 15,16 1969

46
Sol LeWitt

Lines in Four Directions / Superimposed 1234
1969

Ink on paper
33 × 66 (13 × 26)
Private Collection, Paris

47
Sol Lewitt

Plan for Wall Drawing
1969

Ink and pencil on paper
53 × 52.7 (21 × 20¾)
The Museum of Modern Art, New York. D.S. and R.H. Gottesman Foundation

foot squares. Later drawings departed from the strict serial drawing pattern in order to respond to the spaces in which they were situated, but the four line system remained the basis of this work until *c.*1970. Although the first wall drawing was executed by LeWitt, later works were made by assistants from written instructions and diagrams (fig.47). These instructions remain a part of the work, the part which helps to organise or conceptualise what is seen.

These works are conceptually simple and as methodical as LeWitt's structures, and they have a similar level of perceptual density. The starting

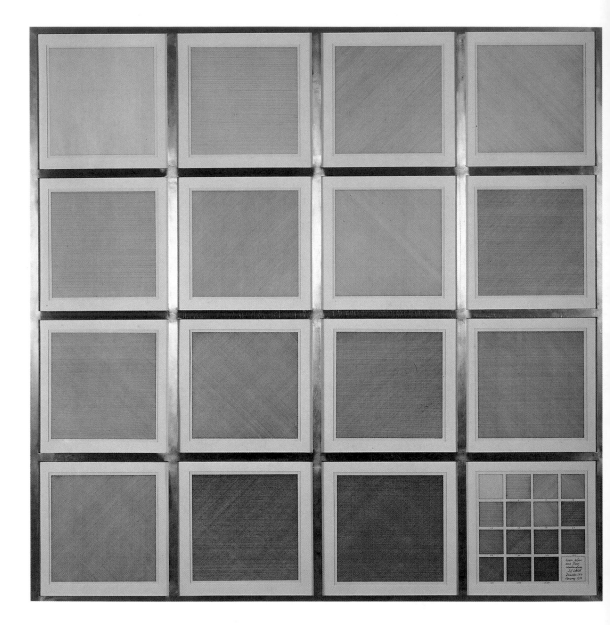

point is a simple text which generates unpredictable results. Being drawn by hand in hard pencil they appear extraordinarily delicate, having a virtual rather than physical presence. Although 'mechanically' executed from instructions, there is room for variation and random effects. The results appear anything but mechanical. In appearance thay are reminiscent of Agnes Martin's hand-drawn grids. In procedure they have something in common with Morris's anti-form works: each is executed in the gallery as an instance of the idea; at the end of the exhibition the work is removed and may be remade in future. Each instance of the work will be different and unique; making it analogous in some respects to the staging of a play (Morris) or the performance of a musical score (LeWitt). In later drawings and wall drawings LeWitt brought colour into the linear system. Unlike Judd, LeWitt reduced his choice of colour to a range of four 'basics' – red, yellow, blue and black – to correspond to the four types of line. But through superimposition an almost limitless variety of new colours can be produced (fig.48). In this way, LeWitt's colour works a little like the optical colour mixture of Flavin's proposals. In more recent works LeWitt has extended his colour range to include the secondary as well as primary colours, and the drawings have evolved into much more fluid, spatial, and dynamic compositions. Nevertheless, a certain conceptual simplicity and laboured methodical execution still underlies the apparently effortless and playful schemes.

FLAVIN

Flavin's work has something in common with that of each of his contemporaries, while being utterly unlike it in other respects. His is more literally 'hard and industrial' than LeWitt's work – the components *are* mass produced – but the effects are often more sensuous and organic and, in some ways, more specific (see, for example, figs.49, 50). For Flavin, as for Andre, the modules of each work are 'readymade', but Flavin's readymade is a finished commodity as opposed to a more 'abstract' industrial product. The work is often based on permutations of a basic module but, unlike a Morris or a LeWitt, the permutations are neither systematic nor exhaustive, and involve colour as much as shape. Colour is something Flavin's work shares with Judd's. Both use available commercial colours – that is, for both colour is a kind of readymade as well as a monochrome – but Flavin's colour is linear and atmospheric rather than planar and local. The linearity of Flavin's proposals define his shapes in a way similar to LeWitt's, but in a way which perhaps has more in common with LeWitt's later wall-drawings than his structures. Unlike Andre's sculptures, Flavin's proposals don't occupy or 'cut into' space so much as permeate it.

Consider for example two proposals made for a large retrospective exhibition in 1989 (figs.49, 50). The structure and size of each work is identical: a regular grid of six horizontal, forward facing units, and six vertical, away-facing units, making an overall composition of 48 × 48 inches.

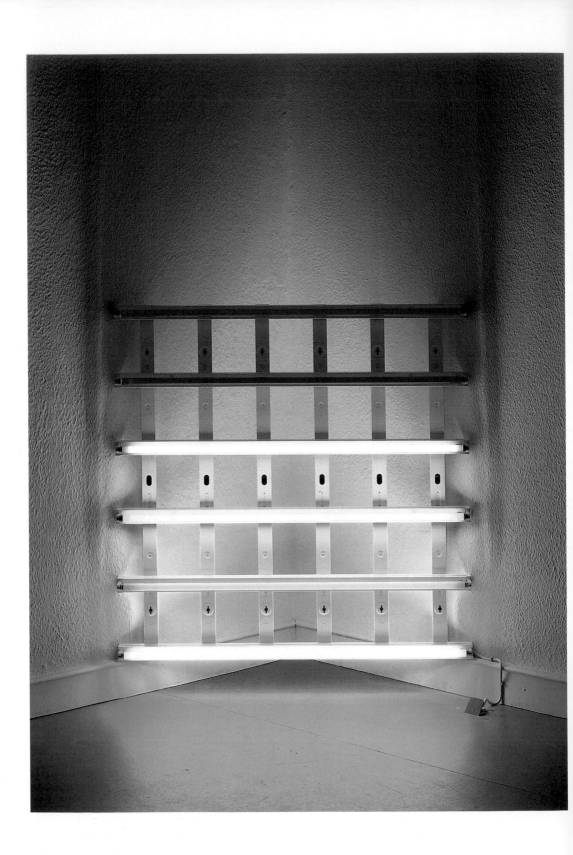

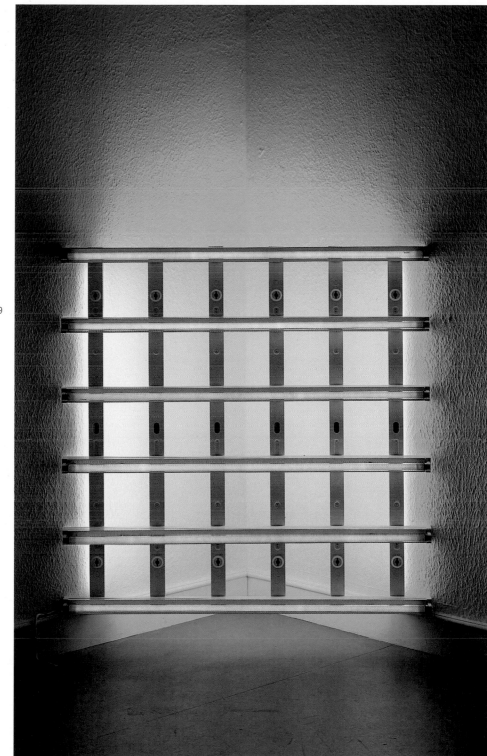

49 *left*
Dan Flavin

*Untitled (for Leo
Castelli at his gallery's
30th anniversary)* 1989

Fluorescent light and
fittings
121.9 × 121.9
(48 × 48)
Installation at
Staatliche Kunsthalle
Baden-Baden, 1989

50
Dan Flavin

Untitled 1989

Fluorescent light and
fittings
121.9 × 121.9
(48 × 48)
Installation at
Staatliche Kunsthalle
Baden-Baden, 1989

Both works are placed across a corner just above the gallery skirting board. No attempt is made to conceal either the holes and other details on the rear of the fittings, or the electric cable leading to the plug socket. To this extent each work is literal, practical, and uncomplicated. But the combination of different coloured tubes in each work produces an effect which is entirely specific, quite complex, and very beautiful. The viewer is left to calculate, if he or she chooses to, the order and colour of the tubes which are hidden from view from looking at the merging pools of coloured light on the walls around them. He or she is also left to reflect on the relationship between the blunt

givens of our material environment, and the hard-to-define specificity which seems to be a precondition of art.

The difficulty with Flavin's work (for art historians at least) is that, after its initiation in 1963, it shows few obvious signs of *development*. (Hence there is no particular difficulty in talking about a recent work before looking at earlier examples.) In 1966 Flavin noted that his work 'lacked the look of history. I have no stylistic or structural development of any significance within my proposal – only shifts in partative emphasis – modifying and addable without intrinsic change'. He added, 'All my diagrams (for the proposals), even the oldest, seem applicable again and continually. It is as though my system

synonomizes its past, present and future states without incurring a loss of relevance. It is curious to feel self-denied of a progressing development, if only for a few years'. Flavin's stress on the lack of development in his post-1963 work may have had something to do with the fact that between 1958 and 1963 his work had been extraordinarily unsettled, shifting between abstraction and figuration; drawing, watercolour and oil painting; assemblages and found objects; photographs and calligram-like poems. But to suggest that his work does not develop is not the same as saying it does not change. Most of the proposals are more complicated than the *Diagonal* of 1963, the starting point of Flavin's non-development. There is an elaboration of linear, square, rectangular, diagonal, serial, grid and other compositions, and a continuous variation in colour – although many of these possibilities were in place by the time of his Green Gallery exhibition in 1964 (fig.51). Tubes and their fittings may be positioned on a wall, floor or ceiling; the light may face the viewer or face the wall, or be used in combination in the same work; the fixtures may lie flat on the wall, straddle a corner, project outward from the wall into space, or run across a space. The material consistency of Flavin's fluorescent work, the use of replaceable components, and relatively (or deceptively) simple compositions does mean that an early work will not look significantly different from a new one. This enabled Flavin to continue a particular strand or series of work over a number of years: between 1964 and 1982, for example, thirty-six versions of the *'Monument' for V. Tatlin* (see fig.3) were completed.

But the *Diagonal*, for all its apparent simplicity and singularity, also contains two more or less distinct possibilities: the production of self-contained object-compositions, and the development of installation-based work. The surrounding space is always implicated in Flavin's work; it is always more than a backdrop. That the architecture could be exploited in the work occurred to Flavin quite quickly. By 1964 he 'knew that the actual space of the room could be disrupted and played with by careful, thorough composition of the illuminating equipment.' 'For example,' he continued, in a 1965 essay in *Artforum*, 'if an eight foot fluorescent lamp be pressed into a vertical corner, it can completely eliminate that definite juncture by physical structure, glare and doubled shadow.' Such a work, probably *pink in a corner (to Jasper Johns)*, was shown in the Green Gallery exhibition (see fig.51, second work on the right). While this was a regular eight foot tube positioned in the corner of the gallery, the clear implication was that the exhibition space might determine not just the placing of the work but its whole form. A page of drawings from 1963 includes a sketch for a work which would be entirely dependent upon the architectural space in which it was set.

Terms like 'installation' and 'site specific' are common currency these days; in the early to mid 1960s precedents were less readily available. It may be – given Flavin's interest in Soviet Constructivism – that he was aware of precedents such as Lissitsky's *Proun Room* of 1923. Certainly he admired the more general move in Constructivism away from easel painting towards a more environmental kind of production which combined 'artistry and engineering'. Calling his own work 'dramatic decoration' implies an architectural interest – as well as an anti-metaphysical reading of this

51
Dan Flavin
Installation at the Green Gallery, New York, 1964

52
Dan Flavin

Untitled (to Dorothy and Roy Lichtenstein on not seeing anyone in the room) 1968–70

Fluorescent light and fittings
Each unit 243.8 (96) high
Installation at the Jewish Museum, New York

particular form of illumination. Rothko, in his later work (from c.1958 to his death in 1971) had sought to 'create a place' with an orchestrated series of paintings, although clearly Flavin was not after the *tragic* drama of the revered elder artist. On the contrary: 'I prefer to refer to my use of artificial light as situational. The lamp lighting should be recognised and used simply, straightforwardly, speedily or, not. This is a contemporary, a sensible, artistic sense. No time for contemplation, psychology, symbolism, or mystery'. Closer in spirit to Flavin's 'situational' art were perhaps some of the installations associated with what became Pop Art – Oldenberg's *Store*, 1961 for example.

To a greater or lesser extent the siting of work became an issue for each of the five artists. For Morris, the conditions of spectatorship were both a theoretical and a practical interest; by 1966 some of Andre's work was being made in response to the exhibition site; LeWitt's Wall Drawings were both temporary and partly determined by the architecture of the gallery; and some, though not so much, of Judd's work was determined by the limits of the exhibition space. Flavin, though, has made more inventive, and more interventionist, use of the gallery space than most of his contemporaries. For example, between 1964 and 1968 he developed ideas for a number of 'barrier' type works which would restrict or block the viewer's passage around a gallery. The first was executed at the Stedelijk Museum in Amsterdam in 1966. The later *Untitled (to Dorothy and Roy Lichtenstein on not seeing anyone in the room)* (fig.52), exhibited at the Dwan Gallery, New York, in 1968, not only physically obstructed the viewer's passage through the gallery by being set in a doorway, but the light faced away from the viewer and illuminated the room to which it simultaneously denied access. Perhaps the 'awkwardness' which Judd saw in Flavin's *Icons* is continued in a different form in these works; certainly the objectness of the work is brought to the attention of the viewer in a strikingly direct way; and equally certainly any idea of metaphysical escape from the quotidian, any inkling of a non-material form of illumination, is emphatically and materially obstructed by these fluorescent barriers.

ANDRE

Carl Andre's *Element Series* remained unmade for lack of funds for over a decade. Although the principal of a modular, placed sculpture was established in Andre's work by 1960, only a few examples were made before 1966. But 1966 looks in retrospect to have been an important year in Andre's work. *Lever* (fig.53) a linear arrangement of 137 firebricks exhibited that year, is, in its stark simplicity, a more adventurous work than his previous modular sculptures. In an interview in 1968, Andre acknowledged that breaking away from the vertical in sculpture had been one of the most difficult steps to take, and credited Judd and Morris with having set the precedent for horizontally oriented work. He likened *Lever* to Brancusi's *Endless Column* laid along the ground; and he came to see his own earlier sculptures as 'too architectural, too

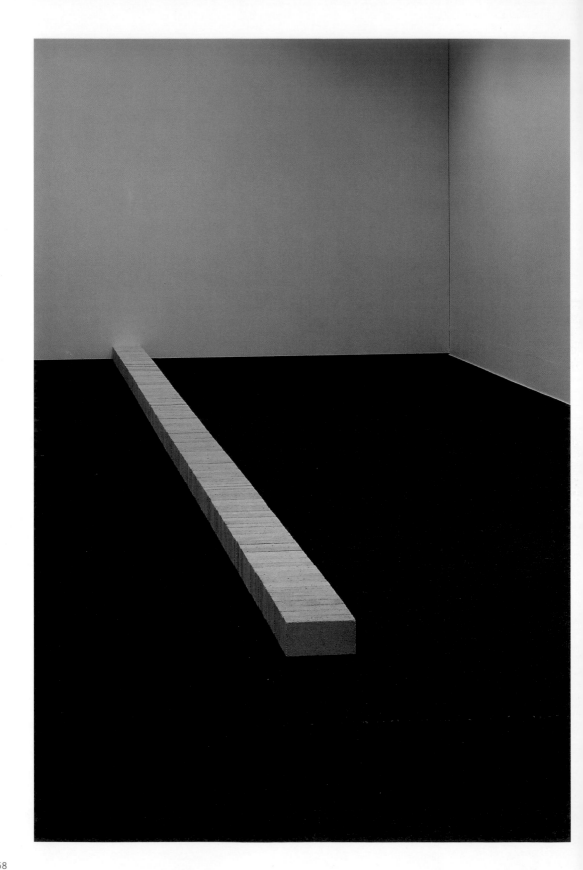

structural', preferring his work to be 'more like roads than like buildings'.

In 1966 Andre also made the *Equivalent* series (see fig.1). These eight permutations of a basic unit comprising 120 particles (bricks) were first exhibited together in one gallery space (fig.54). Less systematic and exhaustive than LeWitt's modular permutations, less provisional than Morris's, the *Equivalent* series is also less 'made' than any other contemporary three-dimensional work, Flavin's included. The sand-lime bricks are acquired from a brickyard and arranged in a studio or gallery; there is little apparent intervening work. At the same time, each work is not simply a readymade. In 1966, to take an industrially produced modular element and to arrange it in a gallery according to a number of simple arithmetical permutations in a regular grid formation, was recognisably the activity of a sculptor, if only just, and if not by everyone. And if there was an ethos of reduction in this

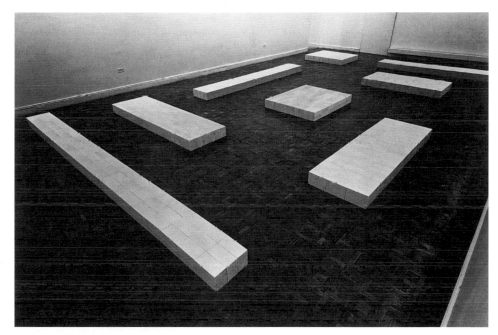

53
Carl Andre

Lever 1966

137 firebricks
Overall: 11.4 × 22.5 ×
883.9 (4½ × 9 × 348)
National Gallery of
Canada, Ottawa

54
Carl Andre

Equivalent I–VIII 1966

Sand-lime brick
Installation at Tibor de
Nagy Gallery, New York,
1966

type of work – the paring away from sculpture of extraneous or unnecessary characteristics – then Andre's was clearly not just sculpture, but some of the most advanced work of its kind around. The eight *Equivalents* are all arranged two bricks deep, in grids of 3 × 20, 4 × 15, 5 × 12, or 6 × 10, and each combination made with the bricks aligned along either their short or long sides. In that sense each work is equivalent to (but not the same as) each other work. Equivalence between works is echoed by equivalence within each work as every 'particle' is very similar. But not the same: in Andre's work variations in colour and surface wear are always visible, and these differences are brought out rather than suppressed. In Morris's or LeWitt's work, on the other hand, variations of this kind would constitute a distraction from the primacy of shape or structure.

In 1968 Andre commented: 'The one thing I learned in my work is that to

make the work I wanted to you couldn't impose properties on materials, you have to reveal the properties of the material'. The statement could be taken in a number of ways. It could represent a commitment to anti-illusionistic sculpture, and could be expressed in his not using any devices for fixing the elements of the work in place. It might also indicate a resistance to conceptualisation, or at least to *naming*. To call a lump of wood a 'post' or a block of compressed sandlime a 'brick' is to impose a property, or a use, upon it and to see it in terms of that use. Elsewhere Andre said of his sculptures: 'their subject is matter'. Like many artists in the modern period, Andre seems to share a concern with the idea of experiencing things for what they *are* rather than for what *use* they may serve. Most of the time we have little choice but to treat things in a generally utilitarian way; we have to get around, feed, clothe and shelter ourselves (assuming we cannot get someone else to do it for us). Art may represent the attempt momentarily to step outside that cycle of experience, in order to look at things in a *dis*interested way, without prejudice and without hierarchy; in a way, that is, where everything would be *equivalent*. The Russian critic Victor Schlovsky discussed the process of 'defamiliarisation', of making the familiar unfamiliar; Berthold Brecht developed the concept of *verfremdungseffect* or 'making strange'. For both Schlovsky and Brecht the value of poetry, drama, literature and art, began and ended with its ability to break the habits of thought, to loosen the chains of convention which bind our senses to the familiar and the functional. That is one of the challenges the modern world lays down to the imagination. For John Cage, the value of Andy Warhol's work – paintings of images, but nonetheless paintings of modules and grids – was that 'by repetition' it was able 'to show us that there is no repetition really, that *everything* we look at is worthy of our attention'. Exactly the same could be said of Andre's *Equivalents*. And something similar could be said about much of the other work we have considered. The simple if impossible ethical imperative to which Cage gave voice in the post-war period – to look at everything as if it were all of equal value, as if it were all equivalent – lies somewhere behind Judd's absorption in the specific qualities of various commercial (that is, not-high-art, relatively vulgar) materials and finishes, from galvanised steel and milled aluminium and marine ply to translucent acrylic sheet and adonising treatments and sprayed laquers. It is also an apt description of Judd's attempt in his later work to allow 'all colours [to] be present at once' irrespective of their position in the heirarchy of the colour circle. Likewise, without some kind of suspension of the distinction between the bland and the beautiful, Flavin's proposals would be merely parodic, which they are not; or, at least, are not in any conventional sense. In a similar vein, LeWitt's convoluted systems and endless series appear entirely indifferent to those conventions and habits which divide the serious from the stupid and the grown-up from the childlike. And in another way, a principle of equivalence is at play in Morris's aim to reconstitute the relationship in his work between object and space and viewer.

In 1967 Andre produced a work which has come to be seen as a pendant to the *Equivalent* series. Titled *8 Cuts* (fig.55) it was an inversion of the object/space relationship of the previous work, and is thus also an equivalent

55
Carl Andre
8 Cuts 1967
Concrete block capstones
Overall: 5.1 × 934.7 × 1,300 (2 × 368 × 512)
Installation at Dwan Gallery, Los Angeles, 1967

of it, even though it is made of different materials and on a different scale. It is difficult not to see the shallow rectangular spaces still as 'figures' against the raised 'ground' of two-inch thick concrete capstones. This in turn indicates how, as Andre reduces the height of his work and increases its lateral spread, the relationship with the floor-plane becomes increasingly significant. It is strange that work more rooted in sculpture than anything around it should almost approach the condition of painting in its dependency on subtle changes in parallel planes of matter, texture and colour.

...es of sculptures made from squares
...lead, magnesium, steel, tin and zinc
...substantial volume and, being hollow, no significant mass, these works have substantial mass, but no significant volume. In fact mass does not really figure in any of the other work we have discussed. Often no more than half a centimetre high, one of these square, rectangular or linear works may be hardly visible if the colour of the metal is similar to that of the gallery floor. And yet it is neither fragile nor ephemeral. It does not force itself on the viewer, but at the same time it is unambiguously present. More than any of the work by the other artists, its presence is quiet and static and almost monastic in its unembellished simplicity.

Throughout this chapter I have stressed the modernity of Minimalist three-dimensional work — as it is represented in choices of industrial forming processes, manufacturing materials, modular compositions, and commercial finishes. But in Andre's work at least there is also a pull in another direction. To (try to) look at something not in terms of its use but in terms of its presence as matter is, in one sense, to detach that matter from its present. In interviews and statements Andre has stressed the importance of two contrasting experiences both of which he has repeated often enough for them to become emblems of his work. The time spent working on the Pennsylvania Railroad is one such experience; the other comes from a visit to England, in 1954, when he was taken to visit the prehistoric sites of Stonehenge and Avebury. Both experiences take the form of emblematic journeys, but of contrasting kinds: one is quintisentially a confrontation with modernity, whereas the other represents a point of contact with an archaic past. The point is that both experiences are related to his work as a sculptor without any apparent sense of contradiction. That is to say, Andre has characterised his work both in terms of a response to the contingencies of the here-and-now and in terms of a deep, almost 'primitive' sense of a relationship with the past. Thus his sculptures show the influence of railroads, which 'have all to do with linear masses . . . a train is a mass of particles'; while at the same time: 'All art is either Palaeolithic or Neolithic: either the urge to smear soot and grease on cave walls or pile stone on stone'.

Andre is not the first artist to have sought to collapse the distinction between different modes of temporality. Just such a demand was at the heart of one of the founding texts of modern art: Charles Baudelaire's 'The Painter of Modern Life'. Written in 1863, it is in part a plea to artists to fuse the 'ephemeral, the fugitive, the contingent' of their modernity with the 'eternal and the enduring' of their inherited traditions, so as to save art from the twin fates of deathly academicism or lifeless illustration. More recently the late Craig Owens cited a doubling of this kind as a key characteristic of the allegorical impulse in both modernist and postmodernist art. In Andre's work we could see this dissolution as undertaken, once again, in the name of *equivalence*.

The pulls of the historically specific and human-in-general may (or may not) contradict each other in theory, but that has never been sufficient reason to dispute their co-existence in art: rather the opposite. The co-existence of contrary states may be exactly the kind of experience which can be shown in art, but cannot be stated in language without apparent contradiction. Despite its apparent simplicity and uniformity, the work we have looked at is replete with contrary relations: the contemporary and the archaic; the adult and the infantile; labour and play; vulgarity and refinement; conceptual simplicity and perceptual complexity; dumbness and eloquence; literalness and resonance; austerity and sensuousness; directness and allusion; blandness and beauty; singularity and multiplicity; purity and hybridity; the material and the uncanny. Furthermore, the work is for the most part made in the spirit of inquiry: inquiry into the real nature of apparent contradiction; inquiry into the relationship between art and non-art, between painting and sculpture,

between the monochrome and the readymade, between the object and the institutional space it occupies. Relatively little is taken for granted, no more perhaps than the aim to make genuinely new art. Just about everything else — what it might look like and what materials and methods might go into it — was open to examination and experiment. What resulted from this moment of inquiry and experiment was an art which didn't retreat from the modernity within which it was made, but which turned the materials and methods of modernity to its own ends.

3

OF TEXTS AND CONTEXTS

To interpret a work of art is to place it within some or other context – a
context of philosophical ideas, or political events, or personal biography, or
other art, or other arts, or whatever. The debate over what counts as an
appropriate context has become a drawn-out war of attrition in academic art
history. For modernists the most relevant and immediate context has always
been other works of art within the same medium. A strong feature of the
three-dimensional work under discussion here is its tendency either to derive
from or to identify with or to parallel work in other media: Judd and painting,
Morris and dance, LeWitt and drawing, for example. For this reason alone it
is not surprising that writers such as Greenberg and Fried were hostile to the
new work. At the same time it is hard not to see their own reassertion of the
independence of the arts from one another during this time as an increasingly
desperate rearguard action in the face of a widely experienced breakdown of
common-sense divisions between categories such as painting and sculpture.
In addition, Greenberg's concept of modernism was premised on an
emphatic distinction between art and non-art, whereas a wide range of
contemporary work increasingly attended to or problematised that
distinction.

The obvious alternative to the highly exclusive theory of modernism, its
through-the-looking-glass form, is the emphatically inclusive theory of the
gesamtkunstwerk, or 'total work of art'. Deriving in part from Wagner's
conception of opera as a site for the intersection and synthesis of all the arts,
the idea of the *gesamtkunstwerk* has taken a number of forms or has been the

motivation behind a number of projects during the twentieth century. The most direct and ambitious example is the Bauhaus of Walter Gropius; but a looser drive towards some form of synthesis marks the work of Kandinsky and Delaunay, Duchamp and van Doesburg, Beuys and Cage. Associated with the idea of artistic synthesis, but logically distinct from it, is the idea, or ideal, of dissolving the distinction between art and non-art, or of merging art with life. In the post-war period, it is most obviously in the work and writing of Beuys and Cage, and in Fluxus events in general, that the aims of synthesis and mergence are articulated. In theory (if only in theory) twentieth-century art may be divided between these two equally powerful and mutually exclusive dynamics: towards autonomy and towards synthesis.

When in 1967 Michael Fried published 'Art and Objecthood', his sustained attack on the 'literalist' work of Judd, Morris, *et al*, it was premised on the two articles of faith in modernist theory: the necessary autonomy of the various arts from one another, and the unambiguous distinction between art and non-art. Anything which went against this Fried labelled 'theatre'; and the relationship between modernism and theatre was simply one of 'war'. For Fried, theatre did not produce a different or a new kind of art but only a degeneration or negation of art, a state where no meaningful concept of quality or value could be applied; and thus the war against theatre was a war for the very 'survival' of the individual arts. At the same time as modernist art had to defeat theatre, it also had to 'defeat or suspend its own objecthood' and, for Fried, objecthood was 'the condition of non-art'. So in direct contrast to Stella's claim that his work was 'really an object', Fried insisted that 'a work of modernist painting or sculpture . . . [is] . . . in some essential respect *not an object*'. (The irony here is that Fried admired Stella's work, and sought to save it from the 'literalist' rhetoric of Judd, and of Stella himself.) The unstressed but key term in this claim is perhaps 'essential', for there is more than one way for a work of art to distinguish itself from the realm of everyday objects. The obvious example of the work of art which is both merely an object, but at the same time more than an object, is the readymade, whose status as art is supplied by a nominal act of displacement. The problem for Fried (and perhaps for aesthetics in general) in the case of the readymade is that 'art' is conferred on an object only contingently, by virtue of a change of context. There is no 'essential respect' in which a urinal is more than an object.

None of the work we considered in the last chapter was a 'simple' readymade. Flavin's comes close, and Andre's perhaps closer, but there is always something in these works which puts them in the realm of the *made* rather than the readymade. But if there is no attempt in these works to disguise or suppress the literalness of the materials from which they are made – or to put it more positively, if there is a concerted attempt in these works not to disguise what they are made from – does that mean they are bound by or condemned to literalness? For Fried it seemed to mean just that; there is no strong distinction in his argument between three-dimensional work and the readymade. In either case there was no transcendence from the literal into the pictorial, and in the absence of the pictorial there was only the theatrical. But

must it be so? Must all art be divided between pictoriality and theatricality? In theory, or in some theories, perhaps it must. But the experience of, say, an Andre might show the possibility of an art which is *neither* pictorial *nor* theatrical, or which is *both* literal *and* allusive. That is to say, the evidence of the work both shows and occupies a space for which there was no logical room in Fried's argument: a space between sculpture and the readymade. Which is presumably why distinctive terms like 'three-dimensional work' and 'objects' and 'structures' were chosen in the first place: to indicate that something *new* was being made, something which demanded a new name.

The idea that there is a productive ambivalence in much Minimal Art between sculpture and the readymade, between the pictorial and the literal, between autonomy and synthesis, is also borne out – albeit unintentionally – in some *post*modernist accounts of the work. The 1995 round-table discussion, by Benjamin Buchloh, Rosalind Krauss and others, on the Reception of the Sixties' is close to a mirror-image of Fried's ultra-modernism. Whereas for Fried 'literalism' failed as art because it negated the necessary pictoriality of sculpture, for Buchloh and Krauss the work of Judd and Flavin (in particular) fails as art principally because it *remains* pictorial, and thus modernist, and thus 'academic'. In this version, only Morris adequately transgressed the boundaries of modernism, and transformed his art in the process. Minimalism, then, is deemed not pictorial enough by some and too pictorial by others. The more interesting question is not who is right, the modernist or the postmodernist, but what it might mean for them, in some sense, *both* to be right. Or to put it another way, if this work consistently fails to stay put within either of the preferred alternative theories of modern art, might this work not lead us to consider what kind of alternatives are on offer?

Fried's argument is pitched at a relatively abstract level, but its feet are set in the concrete of medium specificity and absolute autonomy. A couple of questions arise. A general one: is it really the case that painting and sculpture have developed in isolation from one another in the twentieth century, and if so why are there so many instances of relief, painted and pictorial sculpture? And a more specific one: was it the experience of certain 'literalist' works which confirmed to Fried the validity of modernist theory, or was it his adherence to modernist theory which denied any validity in non-modernist works of art? Relatively little of the discussion in 'Art and Objecthood' takes its point of departure from the experience of particular works of art; much more is developed in response to the writing of Judd, Morris, and Tony Smith. Where work is alluded to, Fried describes it in terms of an experience of 'stage presence', 'hollowness', and 'anthropomorphism'. He goes on to specify 'duration' and 'temporality' as characteristic of this work in contrast to the 'instantaneousness' and 'presentness' of modernist art. But what actual work fits this description? As a summary of Morris's plywood or fibreglass columns, slabs and beams, it is literally quite accurate, and quite close to Morris's own intentions; but it is neither literally *nor* metaphorically close to the work of Andre, Flavin, Judd or LeWitt. Which of these works could be experienced as hollow? Some of Judd's and LeWitt's perhaps, but hardly the

majority, which are open rather than enclosed forms. And not Flavin's or Andre's, in any conceivable sense of the term. It seems likely that Fried took the already and intentionally theatrical work of Morris to represent the threat to modernist pictoriality, and subsumed all adjacent work under the same heading in his narrative of war and survival.

There is one other figure conscripted into the war between pictoriality and theatricality: the viewer. In Fried's account (which is extended and developed in his book on eighteenth-century art and criticism *Absorption and Theatricality*) the exemplary modernist work of art is autonomous also in the sense that its value resides entirely within the work. It exists as if it were entirely independent of its surroundings, and more importantly, as if the viewer did not exist. There may be better or worse viewing conditions, but these will not determine whether it is regarded as art, or how good it is as art. In viewing such work, the argument goes, the viewer is able also to leave aside any local contextual consideration. Or, more to the point, the contingencies of the viewer's time and place are put aside by the work. The result is 'presentness', a moment of transcendence or detachment. By contrast, for Fried, 'literalist' work makes the viewer aware of his or her own presence and of the space in which he or she and the work is situated. Whatever 'presence' (as opposed to presentness) the work has is a product of the relationship established between it and the viewer, and the circumstances under which the work is encountered. We experience the work only in real time and in actual space, that is, just as we experience ordinary objects. Or, as Fried put it in the final sentences of 'Art and Objecthood': 'We are all literalists most or all of our lives. Presentness is grace'. Once again, what for Fried is the negation of art is, for Morris, the condition for its continuation and renewal: it is *only* in work which shifts the viewer's attention from the interior to the exterior, from the private to the public, which takes 'the relationships out of the work and makes them a function of space, light and the viewer's field of vision', that an adequately modern sensibility is addressed, or perhaps created.

Not surprisingly, Fried's writing was not widely admired in Minimalist circles. But the published objections of Judd, Morris, Flavin and others often focused less on the arguments which Fried developed and more on the tone of voice in which they were conducted. Judd's hostility towards the writing of Greenberg and Fried is difficult to miss; his own style of spare and unornamented writing is both the corollary of his art, but also the negation of what he called Fried's 'pedantic pseudo-philosophical analysis'. For Flavin, 'Friedberg and Greenfried' were just 'presumptuous, self-appointed, self-indulgent, self-inflicting ... super-serious (or is it supercilious — well, slight matter) artfully footnotable pious, promo-proto-art historical polemicists'. Morris dryly noted that work such as his 'would undoubtedly be boring to those who long for access to an exclusive specialness, the experience of which reassures their superior perception'. In each instance there is an antagonism to the kind of *culture* which 'Friedberg' is taken to represent. Modernist criticism had come to be seen as defensive, closed and managerial; more rigidly self-serving than rigorously self-conscious, and more prescriptive than perceptive. As a culture it appeared exclusive, academic and over-cultivated.

Following this, the 'war' between pictoriality and theatricality could be redescribed from another angle as a different kind of dispute: one between different cultures, or one between different sections of a culture, each with its own and divergent experiences and expectations of modernity. On the one hand, modernist judgements of value claim to take no account of such experiences, they are deemed irrelevant. Which is not to say that a modernist has to be ignorant of the world which is not art, but he or she must strive for a form of indifference to that world, at least when faced with art. On the other hand, an attachment to the here-and-now is almost always relevant to the making of art, and was explicitly relevant to the three-dimensional work under discussion. This in turn is not to say that the artists sought somehow to dissolve the difference between art and life, or to illustrate modern life in their art, or to make a populist art of any kind. Nor is it to say that the value of such work could be figured out on the basis of some hypothetical device for measuring the levels or quantity of modernity-references. But in some sense the work had to be judged against the world as well as against other art. This much seems obvious. What is always less obvious is just how the relationship between the relative autonomy of art and the experience of modernity is to be negotiated.

We have already looked at how the world of industry, technology and assembly was, in art, also the world of the 'specific object', of the 'flat-bed picture plane', of Pop Art, and (according to Steinberg if not Fried) of the 'fast' abstractions of painters such as Noland and Stella. In much of this work the traditions of studio craft gave way to something more like small-scale industrial production. Not only did Warhol call his studio set-up the 'Factory', but the humanist ideal of the work of art – a uniquely achieved, autographic, unreproducible work born from a struggle between a solitary individual and his resistant materials – began to give way to a more 'alienated' form of production, in which a division of labour between conception and execution, and design and fabrication, was thematised and exploited. The work would thus be like the world in which it was made: images from that world may or may not be depicted, but its processes would be represented and its faces, or its surfaces, would be revealed.

Judd liked to talk of his work as 'direct'; Flavin likes to use his fittings 'straightforwardly'; the forms of Morris's fabricated work were 'simple'; the ideas behind LeWitt's work are 'ludicrously simple'; Andre uses material in its 'clearest form'. They all sought to avoid fussiness, complication and over-refinement, which was evident both in much 'crafted' painting and sculpture, and in the scholastic tone of some contemporary criticism. The new work required a new critical voice, one which was supplied in part by the artists themselves. This voice would have the same qualities as the work; it would be direct, straightforward, hard-and-industrial perhaps. Which is not to say it would not also be thoughtful, perceptive and poetic; but as with the works of art, it would have to find a poetics appropriate to its modernity. In addition, there was perhaps a sense that such work would no longer require a sophisticated professional voice to speak on its behalf, or to mediate between it and the vulgar materiality of the world beyond. This is not to say that *no*

voice would be needed to represent this work and its meanings (although many artists have craved an absolute and unmediated contact between the work of art and its beholder); but a more 'direct' voice might cut across and interrupt the 'pedantic' aloofness of modernist criticism.

It was the particular tone of voice, both of the objects and the writing of Judd, LeWitt and others, which provided Rosalind Krauss with evidence of Minimalism's modernity. Krauss, together with few other critics such as Lucy Lippard, Barbara Rose and Barbara Reise, provided many of the more sympathetic and insightful contemporary commentaries on the work of these artists. Unlike some however, Krauss explicitly opposed a prevailing idealist reading of Minimalist geometry. In this version, the regular and repeated forms of the work were taken as a modern variant of a rational, classical order of measure and proportion, which itself is traditionally taken as evidence of the higher and finer workings of the human mind. In 'LeWitt in Progress', published in 1977, Krauss cites an article by Donald Kuspitt on Sol LeWitt: 'rationalistic, deterministic abstract art links up with a larger Western tradition, apparent in both classical antiquity and the Renaissance, *viz.*, the pursuit of intelligibility by mathematical means. This tradition is profoundly humanistic in import, for it involves the deification of the human mind by reason of its mathematical prowess'. Krauss asks how it is, in a world in which rationalism and humanism seemed to have been abandoned by just about every one, that such a lucid representation of pure reason should come about. And she answers the question by proposing an imaginative alternative interpretation of LeWitt's, and by extension Judd's and others', geometry. This work, she argues, (she has in mind the *Incomplete Open Cubes* in particular) represents not pure reason but almost the exact opposite: the 'outpourings' and repetitiveness of an 'obsessional' mind. 'The babble of a LeWitt serial expansion', she continues, 'has nothing to do with the economy of a mathematician's language. It has the loquaciousness of the speech of children or of the very old, in that its refusal to summarise, to use the single example that would imply the whole, is like those feverish accounts of events composed of a string of almost identical details, connected by "and".'

The model for this work, Krauss argues, is not in the superior logic of Kant or Descartes, but in the compulsive ramblings of a character from *Molloy*, a story by Samuel Beckett. Molloy, the eponymous hero of the narrative, spends a huge amount of time and mental energy devising a system for the circulation of sixteen pebbles through his mouth and the four pockets of his trousers and coat, in a bid to ensure that every pebble is sucked regularly and no one pebble is sucked more often than any other. Molloy's actions are systematic, to be sure, and follow an obstinate logic; there is also attention to detail, neatness, precision, and exactitude. But, as Krauss points out, this doesn't declare his powers of reason so much as cover over 'an abyss of irrationality'.

This anti-rationalist account of Minimalism in fact comes first from the artists themselves. LeWitt was sharply aware of the asymmetrical relationship between logic and rationality, declaring in his terse 'Sentences on Conceptual Art', in 1969: 'Irrational thoughts should be followed absolutely

and logically'. A year earlier, Robert Smithson had written: 'LeWitt is concerned with enervating "concepts" of paradox. Everything LeWitt thinks, writes, or has made, is inconsistent and contradictory. The "original idea" of his art is lost in a mess of drawings, figurings and other ideas. Nothing is where it seems to be. His concepts are prisons devoid of reason'. Judd had earlier attacked the 'rationalism' of European art and never ceased to admire 'the complete omnipresence of chance' that he saw in the work of Pollock and others. A questioning of rationality also motivated much of Morris's 'anti-form' work, and formed a large part of his 1970 essay 'Some Notes on the Phenomenology of Making'. In fact it is hard to think of an artist in the generation or two after Pollock or Cage for whom rationality was anything but a dirty word. In place of reason there was randomness, chance, seriality, repetition and redundancy. Krauss's essay finishes with a passage which is worth quoting in full:

> For LeWitt's generation a false and pious rationality was seen uniformly as the enemy of art ... For this generation the mode of expression became the deadpan, the fixed stare, the uninflected repetitious speech. Or rather, the correlatives for these modes were invented in the object-world of sculpture. It was an extraordinary decade in which objects proliferated in a seemingly endless and obsessional chain, each one answering the other – a chain in which everything was linked to everything else, but nothing was referential.
>
> To get inside the systems of this work ... is precisely to enter a world without a centre, a world of substitutions and transpositions nowhere legitimated by the revelations of a transcendental subject. This is the strength of this work, its seriousness, and its claim to modernity.

To 'get inside the systems of this work' is, for Krauss, obviously not the same as the a-temporal absorption Fried had in mind. Taking up the themes of Judd's early writing and Morris's 'Notes on Sculpture', Krauss argues in other essays that the work of the 1960s developed a 'new syntax for sculpture' which radically redefined the production of meaning and (thereby) the position of the viewer. For Krauss, the concept of 'interiority' is central to the syntax of sculpture before the 1960s. Be it figurative or abstract, organic or architectonic, this work presupposes a naturalistic relationship between interior and exterior, insofar as an outer form is understood to be generated from or built around an inner core. This relationship is itself taken as a metaphor of the psychological interior and physical exterior of the artist, and meaning in this relationship is held to arise from the depths of the artist's private, centred, self.

In its seriality and repetitions, in its avoidance of hierarchy and centredness, in its negation of the interior/exterior model of art, Minimalism also, for Krauss, negated its metaphorical equivalent: the idea that the meaning of such work resides in the subject's inner (private and privileged) psychological life. As is the case with the readymade, the viewer is no longer faced with extracting the psychological subject from beneath the physiognomic surface. But then, if meaning is not *in* the work, where is it? Following the principles of semiotics, Krauss argues that meanings, rather than being inherent in words or objects, are produced only through the

relationships of these with other words or objects. Meaning, that is to say, is produced *externally*, in the public rather than the private sphere; it will always be relative rather than absolute, dependent in some broad sense on context rather than pre-formed and fixed. As an example she cites Morris's *L-Beams* (fig.9), and her commentary brings to mind Morris's own statement about taking 'the relationships out of the work and mak[ing] them a function of space, light and the viewer's field of vision'. For Krauss, that the work implies an awareness of it being situated in a specific context, and that the viewer is in turn made aware of this phenomenology, is further evidence of the work's 'seriousness, and its claim to modernity'.

Not every commentator has seen in Minimalism the absurdism and scepticism and seriousness that so attracted and impressed Krauss. Nor have they seen in its materials and forms and arrangements such a thorough-going critique of the centred humanist self. On the contrary. In 1990, the art historian Anna Chave put forward an interpretation of Minimalist art and writing which headed off in almost exactly the opposite direction. Titled 'Minimalism and the Rhetoric of Power', it set out to show that Minimal Art, far from being produced out of scepticism and doubt, is authoritarian, domineering, and complicit in the perpetuation of existing relations of power. In a nutshell: 'The blank face of Minimalism may come into focus as the face of capital, the face of authority, the face of the father'.

The question underlying Chave's essay is an important one, namely: what is the relationship of this (or any) art with the institutions and mechanisms and rhetoric of power which are the bedrock of any modernity? For Chave, evidence of Minimal Art's complicity is found in a number of areas: in the artists' writings; in the materials and forms of their work; and in the relationship established between the work and the viewer. Certainly, words like 'direct', 'strong', 'aggressive' and 'power' do figure in the writing of Judd and others; and there is a kind of blue-collar bluntness in some (but not all) Minimalist rhetoric. And while this may at the time have been intended as a counter to the privileged language of contemporary art criticism, and perhaps as a form of identification with the interests of a different social class, these days it can come across as less transgressive, and as more aggressive.

When Chave moves from counting gendered adjectives to interpreting the artists' work, her argument takes a different turn. Obviously an image in a painting (especially one of, say, a peasant or a prostitute or a banker or a soldier) will help the historian who wants to move his or her discussion out from the art and into the social world in which it was made. Faced with a range of resolutely abstract work Chave resorts to finding *hidden* images, to inventing an iconography which then becomes the basis for her interpretation. In this scheme Flavin's *Diagonal. . .* (fig.29) 'is clearly phallic . . . alluding to the characteristic angle of an erect penis on a standing man'; Andre's *Lever* (fig.53) 'offers a schematic image of coitus'; Stella's black paintings (fig.14) are like 'those bolts of fine pinstriped wool flannel used . . . to make the suits of bankers, executives and politicians'; Noland's compositions are like 'military emblems'; and Judd's repeated geometric

forms relate to Albert Speer's Nuremberg Parade Ground. Admittedly Chave is helped in her interpretation by an allusion made by Flavin (in a notebook he referred to a drawing of the *Diagonal. . .* as 'the angle of personal ecstacy') and a similar comment made by Andre, but as Krauss and others have shown, there is still no necessary reason to read any of these works as images of anything in order for them to convey meaning. That they can be reinvented as images says nothing substantive about the work, any more than seeing an image in a Rorschach test speaks about the meaning of an ink blot.

Chave goes on to argue that the relationship established between the work and the spectator is tantamount to that between 'bully and victim'. While she has in mind the somewhat later work of the sculptor Richard Serra in particular, a similarly 'aggressive tone' is evident, she suggests, in other Minimalist production. Certainly a list of typical materials used in this type of work might lead one to expect something hard, heavy and unyielding. But the *effects* of a work of art have no necessary relationship with intrinsic qualities of the materials from which they are made. To begin with, none of the work we have discussed is especially large. And it is never solid and monolithic, but always assembled from parts. More particularly, Flavin's and LeWitt's assemblies, for example, are characteristically light and fragile looking; Judd's forms are open and his colour combinations idiosyncratic; Morris's slabs and beams are hollow and adjustable and sometimes appear to float; and Andre's metal 'rugs' may be so thin they are hardly visible. Furthermore, all this work is marked by the regular use of light-coloured or light-reflecting or (in Flavin's case) light-emitting surfaces, the effect of which is always to counteract any intrinsic weight and stability of the object. This is difficult to show in reproduction of course, but attention to one or another form of *lightness* may be one of the few areas of consistency in this diverse range of work. For example, while monochromatic painting has often sought the cover of darkness – think of the blacks of Rauschenberg, Stella and Reinhardt – the three-dimensional work made partially in response to it has almost always steered clear of the deeper tones, and gone for the pale or the bright or the shiny instead. The only possible exception is a certain amount of Andre's work: steel and lead are normally quite dark materials – although tin, copper, aluminium, sand-lime, cedar, etc, are not. To put it another way, while each of the artists aimed to make work with convincing presence of some kind, they all avoided the relatively easy option of conferring presence through mere size or sheer literal weight or through the use of 'heavy' light-absorbing surfaces.

Chave's thesis is difficult to counter, not because it is particularly well argued, but because it is largely stipulative and uses an interpretive methodology based on a form of inuendo. Above all, it is an interpretation which is rooted more in expectation than in response to observation. It is also highly selective in the matter of the artists expressed interests and intentions. In the writing of all the artists there are numerous references and allusions to questions of meaning, spectatorship, the space of the gallery and the museum, the wider political culture and counter-culture, urban space, architecture, the Vietnam war, and so forth, but Chave glosses over these.

This brief and inadequate discussion of three of the more prominent interpretations of Minimalism should at least give an idea of the range and divergent types of narrative that the work of Andre, Flavin, Judd, LeWitt and Morris has given rise to. Finally, there is one other narrative around Minimalism which should be looked at, the most important one of all: the narrative constituted by subsequent works of art.

This discussion has been limited to the work of five artists, but this was always a somewhat artificial limitation. A number of contemporary artists produced work which is clearly related to, and which might also be seen as a continuation or an expansion or a critique of the work we have considered so far. Robert Smithson, Richard Serra and Eva Hesse have all been mentioned in passing. Smithson, one of the most astute if occasional commentators on Minimalism, also exhibited a range of work based on repetition and progressions, usually made of units of commercially available material, although this work often carried a range of natural and geological connotations. Increasingly he came to focus on the issue of site and the concept of entropy, both in his writing and in his later large-scale Earthworks, which were proposed, planned and executed from the late 1960s until his untimely death in 1973. Serra is often most closely identified with Minimal Art for his sculptures made from huge sections of unembellished Cor-Ten steel, or blocks of forged steel. However these are often made on a scale rarely if ever approached by the other artists; they are quite often solid and monolithic; when assembled from parts, each of those parts usually conveys a sense of extreme density and weight; and the works are often dynamic in composition and placing. Like Smithson one of his principle concerns is with site (although the urban sites usually preferred by Serra are a long way from the often remote locations of Smithson's Earthworks); with taking art out of the confines of the gallery and into some kind of public arena; and with a conception of process derived more from Morris's anti-form work than his earlier object-sculptures.

When Carl Andre was asked in an interview in 1996 how he saw sculpture being taken forward, he replied: 'Perhaps I am the bones and the body of sculpture and perhaps Richard Serra is the muscle, but Eva Hesse is the brain and the nervous system extending far into the future'. It is a remarkable tribute to an artist who died in her early thirties, some two decades earlier, but Andre was not alone of his generation in his estimation of Hesse's importance. Consider her *Accession II*, 1969 (fig.56). The work is both like the Minimal Art we have looked at in some respects and unlike it in others. The floor-based, open-topped cube-form is obviously reminiscent of some of Judd's work. The materials are light-industrial: galvanised steel mesh, plastic tubing. The work is not solid but assembled from parts and riveted together. Exterior and interior are equally visible. There is an obsessive-repetitive side to it: the several thousand short lengths of tube hand-threaded through the mesh suggest analogies with some of LeWitt's drawings and structures. The obvious difference is Hesse's use of a non-rigid material, which compromises the austere geometry in a unique way. Unlike Morris's Minimal or Anti-form works, which refer to the human form or actions in a relatively abstract way,

Hesse's work is overwhelmingly *bodily* in its connotations. But not in a way which retreats to a model of sculpture-as-body which Krauss rightly credited Minimalism with having superceded. How so? In part perhaps because Hesse reverses the terms of interiority and exteriority: if there is a narrative of growth in this work it is not outwards from an inner core, but inwards from an outer skin. Smithson's phrase again seems apt: there is an uncanny materiality in this work. Whatever else Hesse's work achieved, she arrived at a sculptural language of the body which was both quite new and (therefore) quite

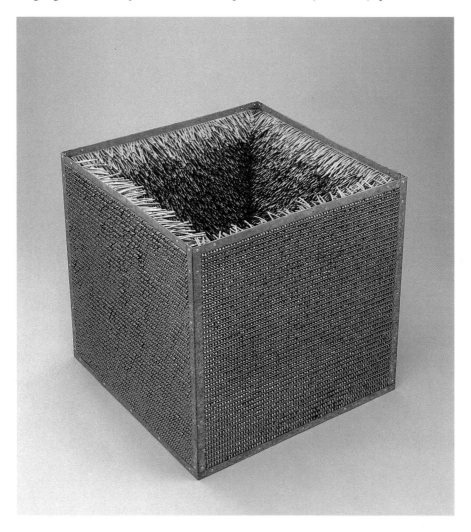

unsentimental. Given the theoretical and artistic attention paid to the theme of 'the body' in recent years, Hesse's work seems in some ways more directly a part of an artistic present than other work we have looked at. But given the naturalism and technical conservatism of much recent sculptural work on the theme of the body, Hesse's concerns might still seem to belong to a future.

Pause.

Damien Hirst's *The Physical Impossibility of Death in the Mind of Someone Living* (fig.57) is a large steel and glass construction, containing a shark suspended in

a formaldehyde solution. Made in 1993, more than a quarter of a century separates this work from the work under discussion in this essay. I am not, of course, claiming it as a work of Minimal Art. Hirst's concerns belong to his own generation and, to some extent, his work has come to exemplify a generation concerned (in ways which Hesse may or may not have recognised) with 'the body', 'the visceral', 'mortality', and so forth. This seems a long way from, say, Judd's art. And yet. And yet these concerns have to be put into the world in some form. Like many artists since the 1960s (from Anish Kapoor to Jeff Koons), and like a great many of his own generation (such as Rachel Whiteread), Hirst takes the format of the Minimalist open box, or shallow tray, or modular cube and inserts a kind of human or at least a bodily content into it. Minimalist form serves these artists as a frame or a grammar through which contemporary subjects may be articulated as art. Hirst comes up with a striking balancing act: the readymade or found object is provided with a

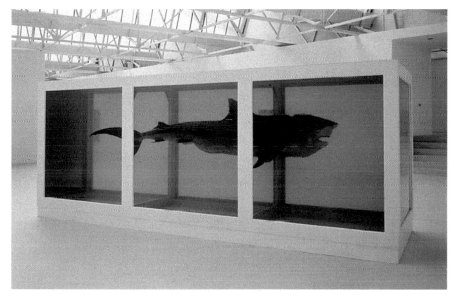

56
Eva Hesse

Accession II 1969

Galvanised steel and rubber tubing
78.1 × 78.1 × 78.1
(30¾ × 30¾ × 30¾)
The Detroit Institute of Art. Founders Society Purchase, Friends of Modern Art Fund and Miscellaneous Gifts Fund

57
Damien Hirst

The Physical Impossibility of Death in the Mind of Someone Living 1991

Tiger shark, glass, steel, formaldehyde solution
213 × 518 × 213
(84 × 204 × 84)
Saatchi Collection, London

frame of reference, while the 'empty' Minimalist box is simultaneously supplied with a content. Of course to see a Judd box as empty is to miss the point of Judd's art. But art is often continued in just this way: by creatively missing the point of earlier art. The work of Hirst and of many others shows, thirty years on, that Minimalism continues to supply a look of modernness and seriousness in art. Repetition and seriality have become a given both of artistic production and exhibition display. Industrial materials and a blank geometry are the starting point of countless artists' work, be it painting, sculpture, photography, or installation. The studio these days is a place where work may be ordered-up as much as made. The work of art these days declares itself relative to the physical and institutional space it inhabits. And the viewer these days is a specific embodied presence before the work. Minimalism may have never existed, but its influence is everywhere.

SELECT BIBLIOGRAPHY

CARL ANDRE

Andre, Carl, Interview with Paul Cummings, in Cummings, Paul, *Artists in their own Words*, New York 1979, pp.173–95

Andre, Carl, Interview with Jeremy Gilbert-Rolfe, 'Commodity and Contradiction, or, Contradiction as Commodity', *October*, no.2, Summer 1976, pp.100–4

Andre, Carl and Frampton, Hollis, *12 Dialogues 1962–1963*, Halifax, Nova Scotia 1981

Batchelor, David, '3000 Years: Carl Andre Interviewed', *Artscribe International*, no.76, Summer 1989, pp.62–3

Carl Andre, exh. cat., Solomon R. Guggenheim Museum, New York 1970

Carl Andre: Sculpture 1958–74, exh. cat., Kunsthalle Bern 1975

Carl Andre: Sculpture 1959–78, exh. cat., Whitechapel Art Gallery, London 1978

Carl Andre: Sculptor 1996, exh. cat., Museen Haus Lange und Haus Esters, Krefeld, and Kunstmuseum Wolfsburg 1996

Carl Andre: Wood, exh. cat., Stedelijk Van Abbesmuseum, Eindhoven 1978

Fuller, Peter, 'Carl Andre on his Sculpture': Pt.1, *Art Monthly* no.16, May 1978, pp.5–6, 8–11, Pt.2, *Art Monthly*, no.17, June 1978, pp.5–6, 8–11

Morphet, Richard, 'Carl Andre's Bricks', *Burlington Magazine*, Nov. 1976, pp.762–67

Siegal, Jeanne, 'Carl Andre: Art Worker', *Studio International*, vol.180, Nov. 1970, pp.175–9

Tuchman, Phyllis, 'An Interview with Carl Andre', *Artforum*, vol.8, no.10, June 1970, pp.55–61

Tuchman, Phyllis, 'Background of a Minimalist: Carl Andre', *Artforum*, vol.16, no.7, March 1978, 29–33

DAN FLAVIN

Dan Flavin: Drawings Diagrams and Prints, 1972–75, exh. cat., Fort Worth Art Museum 1977

Drawings and Diagrams 1963–72 by Dan Flavin, exh. cat., vol.1, St Louis Art Museum 1973

Flavin, Dan, '"… In Daylight or Cool White"', *Artforum*, vol.4 no.4, Dec. 1965, pp.21–4

Flavin, Dan, 'Several more remarks …', *Studio International*, vol.177, no.910, April 1969, pp.173–5

Fluorescent Light, etc from Dan Flavin, exh. cat., National Gallery of Canada, Ottawa 1969

'Monuments' for V. Tatlin from Dan Flavin, 1964–82, exh. cat., Donald Young Gallery with Leo Castelli Gallery for the Museum of Contemporary Art, Los Angeles 1982

New Uses for Fluorescent Light with Diagrams, Drawings and Prints from Dan Flavin, exh. cat., Staatliche Kunsthalle, Baden Baden 1989

Three Installations in Flourescent Light, exh. cat., Kunsthalle, Colone 1974

DONALD JUDD

Agee, William, *Don Judd*, exh. cat., Whitney Museum of American Art, New York 1968

Art + Design: Donald Judd, exh. cat., Museum Wiesbaden 1993

Batchelor, David, 'A Small Kind of Order: Donald Judd Interviewed', *Artscribe International*, no.78, Nov./Dec. 1989, pp.62–7

Donald Judd, exh. cat., Staadliche Kunsthalle Baden-Baden 1989

Haskell, Barbara, *Donald Judd*, exh. cat., Whitney Museum of American Art, New York 1988

Judd, Donald, *Complete Writings 1959–1975*, Halifax, Nova Scotia 1975

Judd, Donald, *Complete Writings 1975–1986*, Eindhoven 1987

Judd, Donald, 'Some Aspects of Colour in General and Red and Black in Particular', *Artforum*, vol.32, no.10, Summer 1994, pp.70–9, 110, 113

Krauss, Rosalind, 'Allusion and Illusion in Donald Judd', *Artforum*, vol.4, no.9, May 1966, pp.24–6

Taylor, Paul. 'Interview with Donald Judd', *Flash Art*, no.134, May 1987, pp.35–7

SOL LEWITT

Batchelor, David, 'Within and Between', in *Sol LeWitt: Structures, 1962–1993*, exh. cat., Museum of Modern Art, Oxford 1993

Krauss, Rosalind, 'LeWitt in Progress', in Rosalind Krauss, *The Originality of the Avant-Garde and Other Modernist Myths*, Cambridge, Mass. 1985, pp.245–59

LeWitt, Sol, 'Paragraphs of Conceptual Art', *Artforum*, vol.5, no.10, June 1967, pp.79–83

LeWitt, Sol, 'Sentences on Conceptual Art', *Art-Language*, vol.1, no.1, May 1969, pp.11–13

LeWitt, Sol, *Sol LeWitt: Critical Texts*, ed. Adachiara Zevi, Rome 1995

LeWitt, Sol, 'Ziggurats', *Arts Magazine*, Nov. 1966 (reprinted in *Sol LeWitt*, exh. cat., Museum of Modern Art, New York 1978)

Sol LeWitt: Drawings 1958–1992, exh. cat., ed. Susanna Singer, Haags Gemeentmuseum, The Hague 1992

Sol LeWitt, exh. cat., Museum of Modern Art, New York 1978

Sol LeWitt: Structures 1962–1993, exh. cat., Museum of Modern Art, Oxford 1993
Sol LeWitt: Twenty-five Years of Wall Drawings 1968–1993, exh. cat., Addison Gallery of American Art, Andover, Mass. 1993

Sol LeWitt: Wall Drawings 1968–81, exh. cat., Wadsworth Atheneum, Hartford, Connecticut

Sol LeWitt: Wall Drawings 1984–1988, exh. cat., Kunsthalle, Bern, 1989

ROBERT MORRIS

Berger, Maurice, *Labyrinths: Robert Morris, Minimalism and the 1960s*, 1989

Buchloh, Benjamin, 'Interview with Robert Morris', *October*, no.70, Fall 1994, pp.47–54

Compton, Michael and Sylvester, David, *Robert Morris*, exh. cat., Tate Gallery, London 1971

Morris, Robert, *Continuous Project Altered Daily: The Writings of Robert Morris*, Cambridge, Mass., London and New York 1993 [includes the articles by Morris listed below]

Morris, Robert, 'Antiform', *Artforum*, vol.6, no.8, April 1968, pp.33–5

Morris, Robert, 'Notes on Sculpture', *Artforum*, vol.4, no.6, Feb. 1966, pp.42–4

Morris, Robert, 'Notes on Sculpture, part II', *Artforum*, vol.5, no.2, Oct. 1966, pp.20–3

Morris, Robert, 'Notes on Sculpture, part III: Notes and Nonsequitors', *Artforum*, vol.5, no.10, June 1967, pp.24–9

Morris, Robert, 'Notes on Sculpture, part IV: Beyond Objects', *Artforum*, vol.7, no.8, April 1969, pp.50–64

Morris, Robert, 'Some Notes of the Phenomenology of Making: The Search for the Motivated', *Artforum*, vol.8, no.8, April 1970, pp.62–6

Robert Morris: The Mind/Body Problem, exh. cat., Solomon R. Guggenheim Museum and Guggenheim Museum, SoHo, New York

GENERAL

Artforum, 'The Artist and Politics: A Symposium', Sept. 1970, pp.35–9

Baker, Kenneth, *Minimalism*, New York 1988

Battcock, Gregory (ed.) *Minimal Art: A Critical Anthology*, New York 1968

Buchloh, Benjamin, 'Conceptual Art 1962–69', *October*, no.5, Winter 1990 (pp.113–15 esp.)

Chave, Anna, 'Minimalism and the Rhetoric of Power', *Arts Magazine*, Jan. 1990, pp.44–63

Colpitt, Frances, *Minimal Art: The Critical Perspective*, Seattle 1990

Foster, Hal, 'The Crux of Minimalism', in *Individuals: A Selected History of Contemporary Art, 1945–1986*, ed. Howard Singerman, Los Angeles 1986, pp.162–83

Foster, Hal (ed.), 'Theories of Art after Minimalism and Pop', with contributions from Michael Fried, Rosalind Krauss and Benjamin Buchloh, in *Discussions in Contemporary Culture*, Seattle 1987, pp.55–118

Fried, Michael, 'Art and Objecthood', *Artforum*, vol.5, no.10, June 1967, pp.12–23; revised version in Battcock 1968

Fried, Michael, 'Shape as Form: Frank Stella's New Paintings', *Artforum*, vol.5, no.3, Nov. 1966, pp.18–27

Fried, Michael, *Three American Painters: Kenneth Noland, Jules Olitski, Frank Stella*, exh. cat., Fogg Art Museum, Cambridge, Mass. 1965

Greenberg, Clement, 'Modernist Painting', in *Collected Essays and Criticism*, vol.4, ed. John O'Brian, Chicago 1993, pp.85–93

Greenberg, Clement, 'Recentness of Sculpture', in *Collected Essays and Criticism*, vol.4, ed. John O'Brian, Chicago 1993, pp.250–6

Greenberg, Clement, 'The New Sculpture', in Clement Greenberg, *Collected Essays and Criticism*, vol.4 , ed. John O'Brian, Chicago 1993, pp.55–61

Haskell, Barbara, *BLAM!: The Explosion of Pop, Minimalism, and Performance 1958–64*, exh. cat., Whitney Museum of American Art, New York 1984

Krauss, Rosalind, 'The Double Negative: A New Syntax for Sculpture', in *Passages in Modern Sculpture*, Cambridge, Mass., and London 1977, pp.243–88

Krauss, Rosalind, 'Grids', in Rosalind Krauss, *The Originality of the Avant-Garde and Other Modernist Myths*, Cambridge, Mass. 1985, pp.8–22

Krauss, Rosalind, et al, 'The Reception of the Sixties', *October*, no.69, Summer 1994, pp.3–21

Leider, Philip, 'American Sculpture at the Los Angeles County Museum of Art', *Artforum*, vol.5, no.10, June 1966, pp.6–11

Leider, Philip, 'Literalism and Abstraction: Frank Stella's Retrospective at the Modern', *Artforum*, vol. 8, no.8, April 1970, pp.44–51

Lippard, Lucy, *Changing: Essays in Art Criticism*, New York 1971

Lippard, Lucy and Chandler, John, 'The Dematerialisation of Art', *Art International*, Feb. 1968

Reise, Barbara, '"Untitled 1969": A Footnote on Art and Minimal Stylehood', *Studio International*, vol.177, no.910, April 1969, pp.166–72

Rose, Barbara, 'ABC Art', *Art in America*, vol.53, no.5, Oct.–Nov. 1965, pp.57–69; revised version in Battock 1968

Rubin, Lawrence, *Frank Stella, Paintings 1958–65: A Catalogue Raisonné*, New York 1986

Rubin, William, *Frank Stella*, exh. cat., Museum of Modern Art, New York 1970

Schwarz, K. Robert, *Minimalists*, London 1996

Scott, Tim, et al, 'Colour in Sculpture', *Studio International*, vol.177, no.907, Jan. 1969, pp.21–4

Smithson, Robert, *The Writings of Robert Smithson*, ed. Nancy Holt, New York 1979

Steinberg, Leo, 'Other Criteria', in Leo Steinberg, *Other Criteria*, London, Oxford and New York 1972, pp.55–91

Studio International, vol.177, no.910, April 1969 [issue on Minimalism]

Tuchman, Phyllis, 'Minimalism and Critical Response', *Artforum*, vol.15, no.9, May 1977, pp.26–31

Wollheim, Richard, 'Minimal Art', *Arts Magazine*, vol.39, no.4, Jan. 1965, pp.26–32; reprinted in Battcock 1968, pp.387–99

Photographic Credits

All photographs are by the Tate Gallery Photographic Department except those listed below.

The publishers have made every effort to trace all the relevant copyright holders; for archive photographs in particular, such information is occasionally not available to us. We apologise for any omissions that may have been made

Courtesy Annely Juda Fine Art, London 34; David Batchelor 18, 25, 32, 33; Rudolph Burckhardt 9, 21, 51; courtesy Leo Castelli 23; Centre Georges Pompidou, Paris / photo Adam Rzepka 26; Philip A. Charles 35; courtesy Jeffrey Deitch 45; The Detroit Institue of Art 56; Hollis Frampton 24; courtesy Paula Cooper Gallery, New York 54, 55; courtesy Paula Cooper Gallery, New York / photo David Allison 28; courtesy Paula Cooper Gallery, New York / photo James Dee 20; Gamma One Conversions, New York 14; Donald Judd Estate 19, 40, 43; courtesy Lisson Gallery, London 44; © National Galleries of Scotland / photo Tom Scott 8; Oeffentliche Kunstsammlung Basel / photo Martin Bühler 27; Kröller-Müller Museum, Otterlo 48; Eric Mitchel 29; © 1997 The Museum of Modern Art, New York 4, 12, 17, 30, 47; National Gallery of Canada, Ottawa 39, 53 (and frontispiece); Norton Simon Museum, Pasadena 41; courtesy PaceWildenstein, New York 13; Saatchi Collection, London 57; Philipp Schönborn 49, 50; courtesy Susanna Singer 7, 46; courtesy Solomon R. Guggenheim Museum, New York 9, 22, 37, 38; © The Solomon R. Guggenheim Foundation, New York / photo Rafael Lobato 31 (on cover); Stedelijk Museum, Amsterdam 11; Joseph Szaszfai 36; Tate Gallery Photographic Department 1, 2, 3, 6, 10, 15, 16; Whitney Museum of American Art, New York 42; Ellen Page Wilson 5; courtesy Donald Young Gallery, Seattle 52

Copyright Credits

Works illustrated are copyright as follows:

Andre: © Carl Andre/ DACS, London/VAGA, New York 1997

Judd: © Estate of Donald Judd/DACS, London/ VAGA, New York 1997

Brancusi: © ADAGP, Paris and DACS, London 1997

Flavin, LeWitt, Morris, Pollock, Stella, Warhol: © ARS, NY and DACS, London 1997

Hesse: © The Estate of the Artist 1997

Hirst: © The Artist 1997

Johns: © Jasper Johns/ DACS, London/VAGA, New York 1997

Louis: © The Artist 1997

Rauschenberg: © Robert Rauschenberg/DACS, London/VAGA, New York 1997

INDEX